BIRMINGHAM
SPORTS & RECREATION

From Old Photographs

ERIC ARMSTRONG &
ROSEMARY STAFFORD

AMBERLEY

Acknowledgements

Chris and Rosemary Clegg did a signal service to cinemagoers in Birmingham and beyond by writing and producing *The Dream Palaces of Birmingham* (1983, ISBN 09509272 1X). We are indebted to their work.

First published 2012

Amberley Publishing
The Hill, Stroud
Gloucestershire, GL5 4EP

www.amberley-books.com

British Library Cataloguing in Publication Data.
A catalogue record for this book is available from the British Library.

ISBN 978 1 4456 0740 5

Typeset in 10pt on 12pt Sabon.
Typesetting and Origination by Amberley Publishing.
Printed in the UK.

Introduction

At the beginning of the last century, Birmingham, by then a major city, was well-placed to stage and encourage significant sporting activities like soccer and athletics. That process had been made more effective because those sports, and others, had become organised on a national basis. The Professional Football League had been founded in 1888, the Football Association in 1863 and the FA Cup competition in 1871. The AAA (Amateur Athletic Association) had been formed in 1880.

Although living standards generally remained poor, they gradually improved, enabling, for example, thousands of supporters to pay at turnstiles to watch, cheer, groan, boo and whistle at Villa Park, St Andrew's and neighbouring Hawthorns. Improved transport services, notably electric trams and later motor buses, played an important part in this development.

As the leisure time for workers slowly increased, so did the range of sporting and recreational activities. For example, special indoor rinks were built for roller skating and later for ice skating. During the 1920s a new 'craze' imported from Australia entered the sports arenas: dirt track, i.e. speedway, racing. Greyhound racing attracted many punters. To the old and traditional forms of the theatre and music hall was added the cinema. The pioneer picture houses of the 1910s and 1920s, which showed silent films and made Charlie Chaplin a global star, paved the way for the 'talkies' and vastly increased audiences.

Recreation at home such as board and card games seemed very tame when first the cat's whisker crystal radio and then the valve radio were introduced in the 1920s to work their marvellous magic. Families sat entranced by the fireside, listening intently to *Band Wagon* and *Toytown*, but not the shipping forecast. During the same period another marvel held its listeners rapt: the wind-up gramophone and its 78 rpm shellac records. Mostly by the use of old postcards, this book provides pictures of nearly forty sports and forms of recreation to be found in Birmingham between 1900 and 1939.

As now, sports were competitive; successful participants expected and received prizes, but in many sports money prizes were taboo. Money broke beyond repair the amateur code of behaviour that was widely adopted. However, fudges crept in and a runner, for example, might find himself winning a canteen of cutlery or a mantelpiece clock. But for the most part, the greatest rewards came in the form of cherished medals, badges, cups and shields. Examples of such 'gongs' will appear in many of the groupings that follow, especially in athletics, gymnastics and swimming. Professional soccer had its own code of behaviour, but still valued medals and silverware.

What is shown overleaf is part of a page from a handsome catalogue issued by the Birmingham firm of Joseph Fray Ltd.

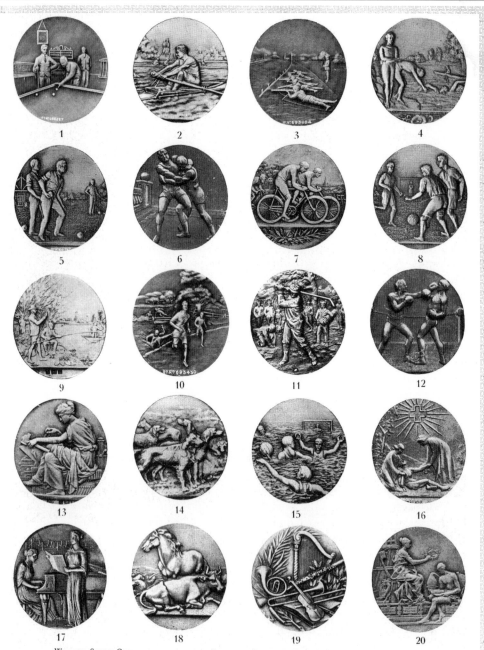

1 2 3 4

5 6 7 8

9 10 11 12

13 14 15 16

17 18 19 20

WE HAVE SHIELD CENTRES FOR NEARLY EVERY SPORT AND PASTIME, A FEW OF WHICH ARE ILLUSTRATED ABOVE.
THE MODELLING OF THE FIGURE WORK IS FIRST-CLASS AND IN HIGH RELIEF.

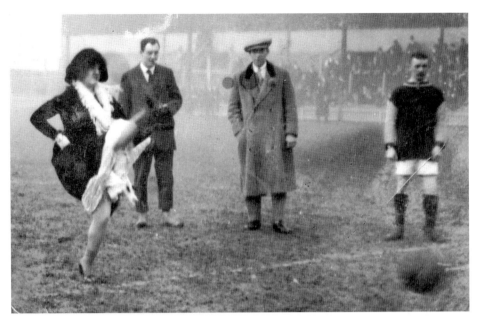

A remarkable and revealing kick-off by Miss Ray Ford. This music hall actress appeared in silent films in their early days (1912–1915) – on one occasion with Oliver Hardy, before he teamed up with Stan Laurel. The football match is thought to have been for charity and staged at Villa Park or St Andrews *c*. 1912. The possible verdict of the crowd might well have been, 'A real sport, that wench!'

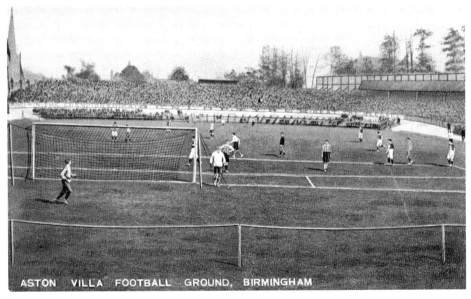

This view is thought to date from around 1902. The Villa now playing at their new ground, opened in 1897. This is a coloured card which reveals that the Villa players are those in white knicks. Around the pitch runs a banked cycling track. A high fence can be seen, right. This was built to prevent 'loafers' from watching the match for free from the slope in Aston Park, which adjoined Trinity Road.

H. SPENCER, Aston Villa,
has figured in an International as far back as 1897, when he gave a great
display of defensive work. He shows good, brainy football, and, when at
the top of his form, is an object lesson on how to play the game.

During the early years of the last century, Howard Spencer was one of Villa's popular stalwarts. This 'Prince of Full-backs' played nearly 300 games for the club and was capped for England six times. He became a club director, serving on the board for nearly thirty years.

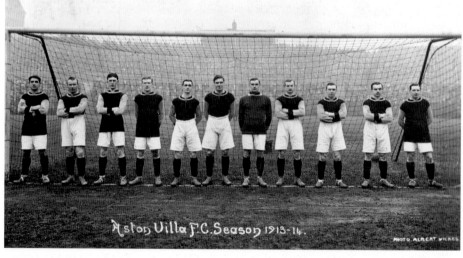

Aston Villa F.C. Season 1913-14.

Is this a radical departure from the then conventional formation of 5-3-2-1? Unsurprisingly, no; 0-0-0-11 was just an unusual way of taking a photograph of a successful team. Villa had won the FA Cup in 1913. This card is franked 22 August 1914 and mentions 'these trying times', a reference, no doubt, to the First World War, as Britain had gone to war on 4 August that year.

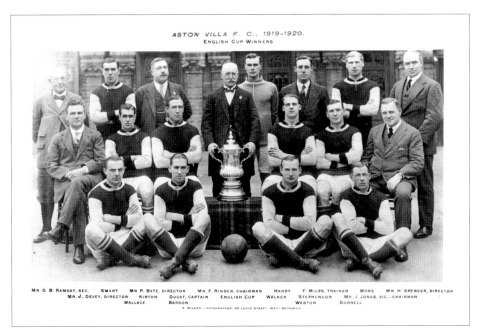

The team that won the FA Cup for the record sixth time. Howard Spencer, now in his director's strip, can be seen, right. Mr Rinder served on the club's committee for many years and during the 1890s he was instrumental in having turnstiles installed. This vastly improved the club's finances.

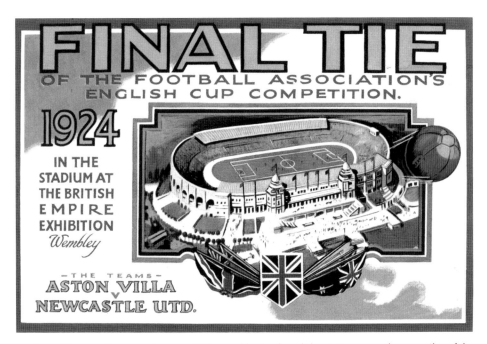

Against widespread expectations that Villa would win, they did not. However, the turnstiles of the new (1923) Wembley Stadium clicked well that day, the attendance being 91,695.

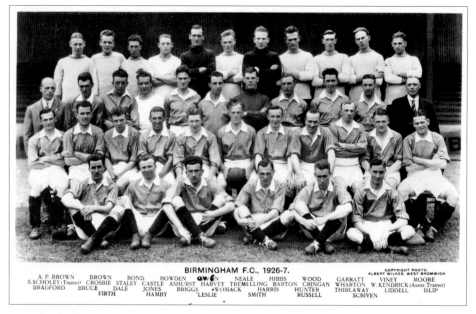

BIRMINGHAM F.C., 1926-7.

COPYRIGHT PHOTO
ALBERT WILKES, WEST BROMWICH

A. P. BROWN BROWN BOND BOWDEN OWEN NEALE HIBBS WOOD GARRATT VINEY MOORE
S. SCHOLEY (Trainer) CROSBIE STALEY CASTLE ASHURST HARVEY TREMELLING BARTON CRINGAN WHARTON W. KENDRICK (Assist. Trainer)
BRADFORD BRUCE DALE JONES BRIGGS WOMACK HARRIS HUNTER THIRLAWAY LIDDELL ISLIP
FIRTH HAMBY LESLIE SMITH RUSSELL SCRIVEN

'The Blues' were formed in 1875, just a year later than the Villa. In general terms, they have never achieved the same levels of success and fan support as the rival 'Claret and Blues'. However, they produced two goalkeepers who served England well on many occasions; Harry Hibbs, between the wars, and Gilbert Merrick, after the Second World War. Below, Hibbs gives some advice to would-be 'custodians of the goal mouth'.

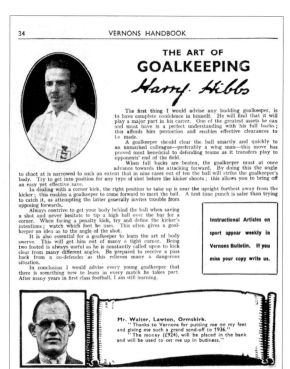

34 VERNONS HANDBOOK

THE ART OF
GOALKEEPING
Harry. Hibbs

The first thing I would advise any budding goalkeeper, is to have complete confidence in himself. He will find that it will play a major part in his career. One of the greatest assets he can and must have is a perfect understanding with his full backs; this affords him protection and enables effective clearances to be made.

A goalkeeper should clear the ball smartly and quickly to an unmarked colleague—preferably a wing man—this move has proved most beneficial to defending teams as it transfers play to opponents' end of the field.

When full backs are beaten, the goalkeeper must at once advance towards the attacking forward. By doing this the angle to shoot at is narrowed to such an extent that in nine cases out of ten the ball will strike the goalkeeper's body. Try to get into position for any type of shot before the kicker shoots; this allows you to bring off an easy yet effective save.

In dealing with a corner kick, the right position to take up is near the upright furthest away from the kicker; this enables a goalkeeper to come forward to meet the ball. A first time punch is safer than trying to catch it, as attempting the latter generally invites trouble from opposing forwards.

Always contrive to get your body behind the ball when saving a shot and never hesitate to tip a high ball over the bar for a corner. When facing a penalty kick, try and define the kicker's intentions; watch which foot he uses. This often gives a goalkeeper an idea as to the angle of the shot.

It is also essential for a goalkeeper to learn the art of body swerve. This will get him out of many a tight corner. Being two footed is always useful as he is constantly called upon to kick clear from many different angles. Be prepared to receive a pass back from a co-defender as this relieves many a dangerous situation.

In conclusion I would advise every young goalkeeper that there is something new to learn in every match he takes part. After many years in first class football, I am still learning.

Instructional Articles on sport appear weekly in Vernons Bulletin. If you miss your copy write us.

Mr. Walter, Lawton, Ormskirk.
"Thanks to Vernons for putting me on my feet and giving me such a grand send-off to 1936."
"The money (£924), will be placed in the bank and will be used to set me up in business."

Excerpt from *Vernons Handbook* of 1936/37.

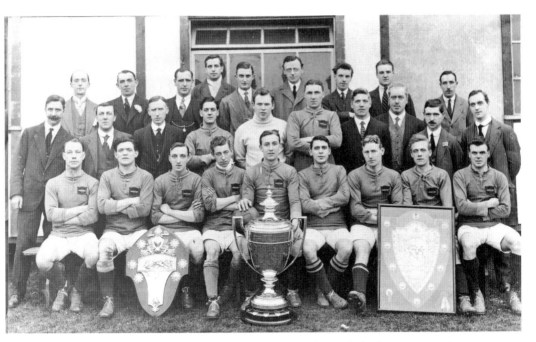

Amateur football teams are often location-based, as here. The card's back conveys a poignant message: 'Remembrance Drews Lane Football Team Xmas 1918 Birmingham'. This must be a reference to the players, and perhaps club supporters, who had lost their lives in the First World War, which ceased on 11 November 1918. Drews Lane is in Washwood Heath.

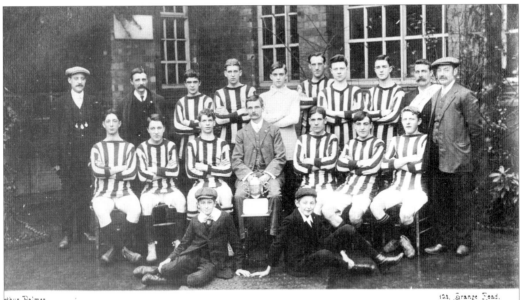

LITTLE BROMWICH E.M.S. FOOTBALL CLUB.

Most probably a pre-First World War team. It includes EMS in its title, which may stand for Evangelical Missionary Society. It was in Little Bromwich that the city's fever hospital was located. Containing some 750 beds, this hospital handled cases of infectious disease.

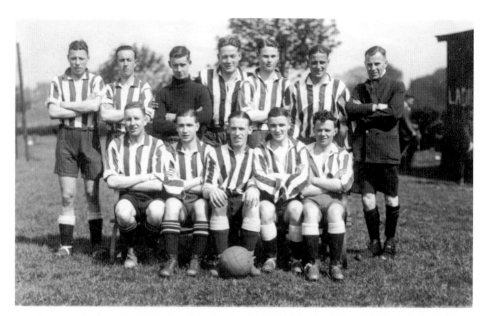

In very neat block letters, this team's captain, R. Wareing, has written the names and positions of each player of Gravelly Hill AFC (Amateur Football Club) season 1933/34. The captain played at inside-left and the centre-forward, L. H. Pearson, the ball at his feet, is sitting to his left. B. Wareing, presumably the skipper's brother, plays at inside-right. The odd-man-out, standing right, is H. S. Green, the referee.

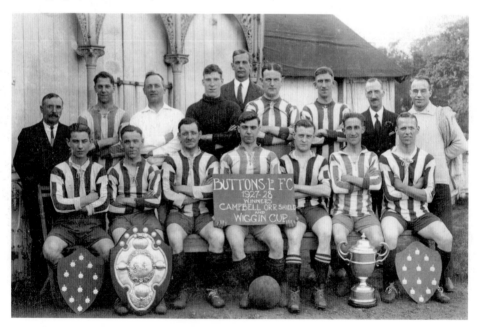

Many Birmingham factories of varying sizes, established works' teams from their employees. Another example follows. For a number of years the city was pre-eminent in the manufacture of buttons. The firm mentioned above ran three works in 1913, at Portland Street, Warstone Lane and Clissold Street, making buckles, stampings and buttons.

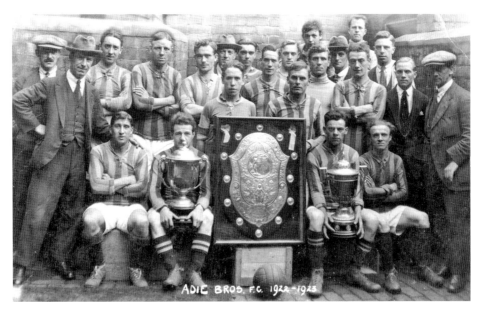

Obviously top-notch footballers, this firm also constituted top-notch silversmiths, their Atlas Works being located in Soho Hill, Handsworth.

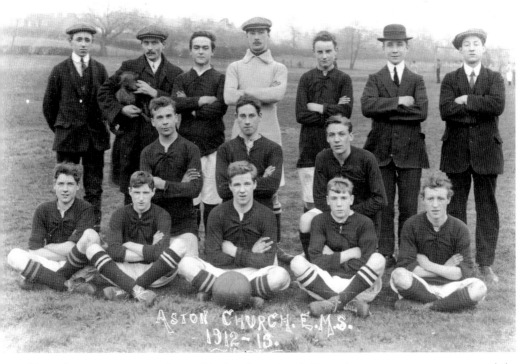

Not a few teams were associated with church or chapel. Given the expansive open area around the team, the photograph may have been taken in Aston Park. The grouping follows the conventional format: goalie, two backs, three half-backs (the middle man being known as centre-half) and five forwards. Again, EMS appears. The dog may be the team's mascot.

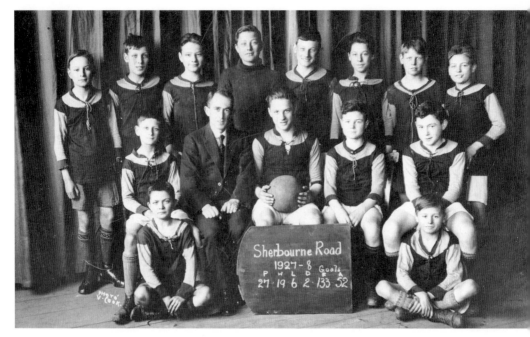

While many old boys of schools formed teams, it was probably boys still at school who played with the greatest enthusiasm and gusto. Sherbourne Road School was located in Highgate. The team's strip bears a resemblance to that of Aston Villa. The statistics shown are impressive, not least the average of nearly five goals a game scored by the side.

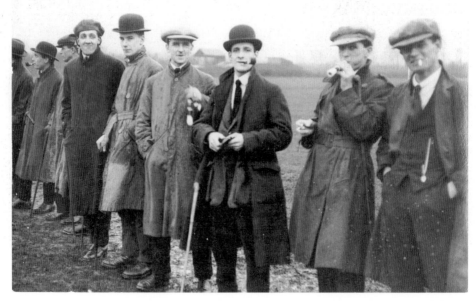

Come rain, come shine, spectators are a dogged lot. Thousands turn up on the terraces and in the stands, but probably every amateur team has its steady following – in the parks and recreation grounds, on private club pitches and those of firms, large and small. This group are watching a 'Saltley Soccer Match Season 1919/20'. No man is hatless.

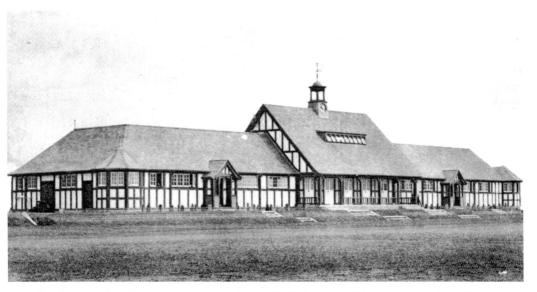

For the same shared reason, institutions of many kinds, lay and religious, introduced greatly improved facilities for sporting and recreational activities. (Fort Dunlop Pavilion.)

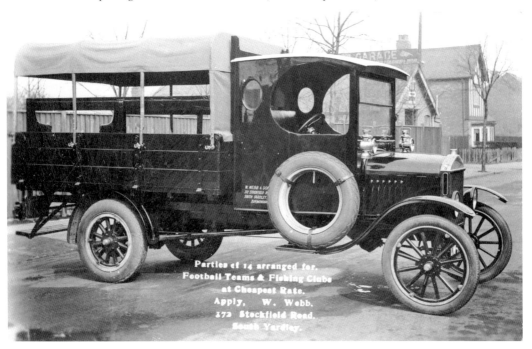

Clearly Mr Webb has a sharp eye for a possible business opportunity; 'could be a nice little earner', in modern parlance.

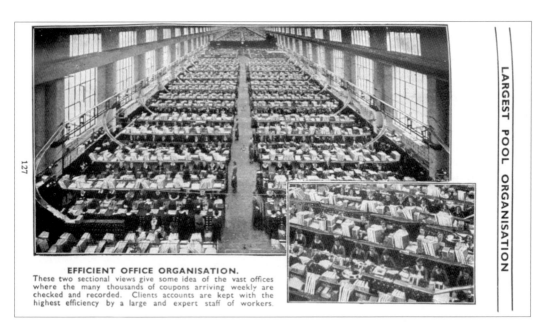

127

EFFICIENT OFFICE ORGANISATION.
These two sectional views give some idea of the vast offices where the many thousands of coupons arriving weekly are checked and recorded. Clients accounts are kept with the highest efficiency by a large and expert staff of workers.

Through much of its history, professional football has encountered perennial problems. These include far too many referees with defective eyesight, the interpretation and application of the off-side rules, the appropriate remuneration for players. Gambling on match results did not become a problem, for with the appearance and growth of the 'pools' firms of the 1930s, such as Littlewoods, Vernons and Shermans, the man-in-the-street was afforded ample scope for a flutter. (Littlewoods Football Annual 1936/37, page 127)

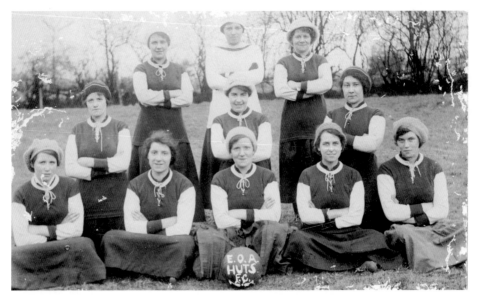

The number, formation, and white jersey suggests this is far more likely to be a football than a netball team. The almost ankle-length dresses suggest this is a pre-First World War photograph, or one taken during that war. Given the 'huts' on the ball are they munitions workers in temporary accommodation? The upper part of the strip is very reminiscent of Aston Villa's. Ladies' football has a longer history than is often supposed.

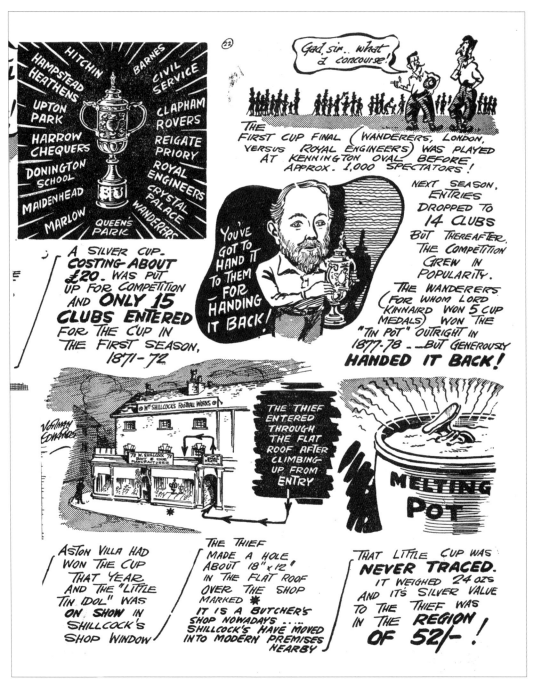

Turning to the formative years of Aston Villa, this club had lifted the FA Cup in 1895, only to have it lifted again in an altogether different manner! The cup had been on display for the public to admire. An incident of great interest in football history. (from *The Story of Aston Villa*, Norman Edwards)

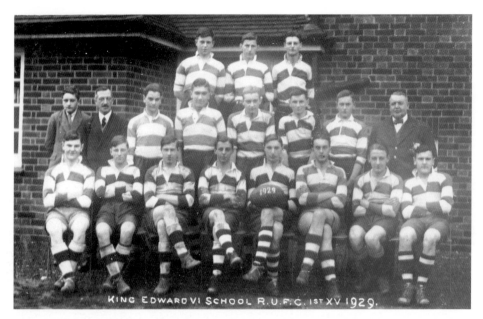

KING EDWARD VI SCHOOL R.U.F.C. 1ST XV 1929.

Although soccer football was far more popular than rugby, or 'rugger', the game (Union, not League) had a loyal following in the city. The grammar schools of the King Edward VI's Foundation played rugby, and George Dixon's School as well. At senior level, Moseley was the Birmingham team, with fixtures against more famous clubs such as Gloucester, Leicester and Wasps.

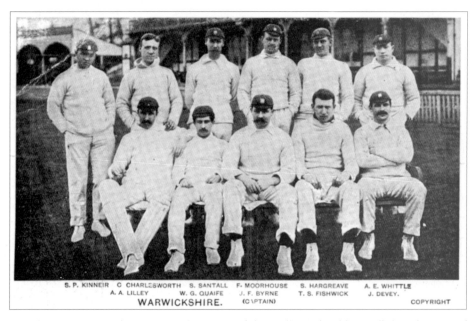

| S. P. KINNEIR | C. CHARLESWORTH | S. SANTALL | F. MOORHOUSE | S. HARGREAVE | A. E. WHITTLE |
| A. A. LILLEY | | W. G. QUAIFE | J. F. BYRNE | T. S. FISHWICK | J. DEVEY. |

WARWICKSHIRE. (CAPTAIN) COPYRIGHT

For whatever reasons, the county cricket teams of the Midlands fared less well than the stars of the North – Yorkshire and Lancashire – and of the South – Middlesex and Surrey. Having been founded in 1868, it took until 1911 for Warwickshire to become county champions for the first time. Quaife and Lilley played test matches for England between 1896 and 1909, Lilley gaining thirty-five caps and Quaife seven.

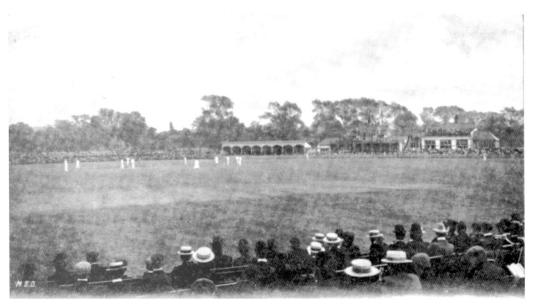

A visit of the Tykes (Yorkshire) would certainly increase attendance at the Edgbaston ground, acquired and opened in 1886. This ground and its facilities eventually gained test match status. The card is franked 1903.

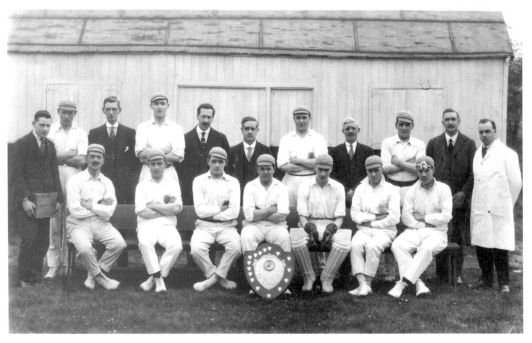

On the back of this card is stamped 'Castle Bromwich Advertiser', no doubt the local newspaper. As in football, clubs were often related to a locality, church or chapel, or formed by old boys from the same school. The team above has obviously enjoyed a successful season. It is worth pointing out that the Birmingham and District Cricket League is the oldest cricket league – founded 1888.

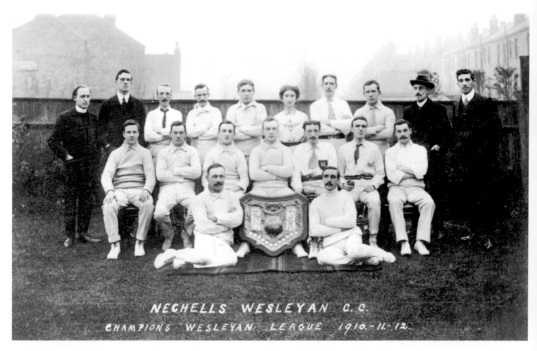

NECHELLS WESLEYAN C.C.
CHAMPIONS WESLEYAN LEAGUE 1910.-11.-12.

Another successful team. As fourteen players are shown, team membership obviously changed from time to time as could be expected. Winning three years in a row conventionally allowed a team to retain the trophy in perpetuity but it was open to a club to hand it back. The young lady may be the scorer.

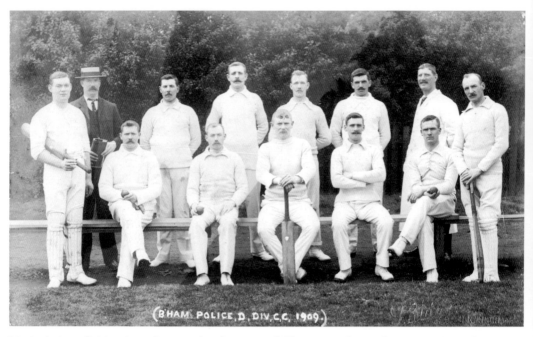

(B'HAM POLICE, D. DIV. C.C. 1909.)

No doubt inter-divisional matches were keenly contested. The army-style 'stand at ease' seems to have been adopted by the back row. Those sitting do so with backs straight. One man wears the long white coat of an umpire.

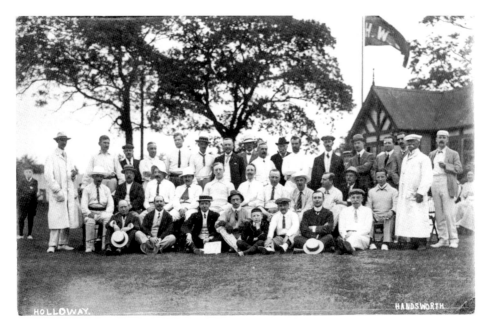

On the back of this card is written, 'Cricket Match of These and Those on Rugby Football Ground Handsworth Wood Road Summer 1910'. Possibly a one-off match played in the spirit of a bit of a lark. It is clear that an important element of the appropriate dress code was the wearing of a tie. On the flag, H. W. must surely mean Handsworth Wood.

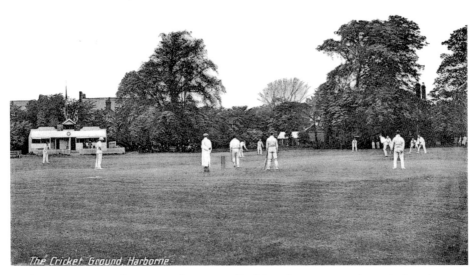

Harborne, once a small country village in Staffordshire, became part of Birmingham in 1891. Harborne's Cricket Club was founded way back in 1868. Its ground, shared with the local hockey club, became a barrage balloon station during the Second World War. This card of a very English scene is franked 1908. A successful veteran of a club.

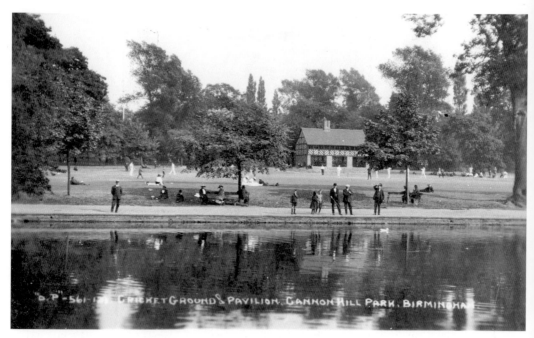

A pavilion worthy of one of the city's two best parks, the other being Handsworth, which had a large flat area designated as the cricket ground. Small groups of spectators are lolling about at a distance. Card franked 26 July 1923.

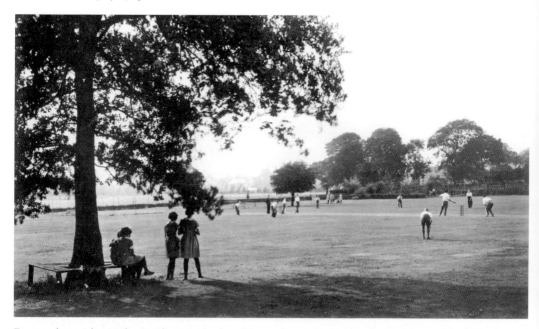

Four orphan girls watch a cricket match played by orphan boys (1937). Josiah Mason did well out of his penmaking factory but much of his wealth was used to found an orphanage, opened in 1869 in Erdington. Later in the century, this Victorian philanthropist founded Mason's College in Edmund Street in Birmingham's city centre. This became the nucleus for Birmingham University. Mason was deservedly knighted.

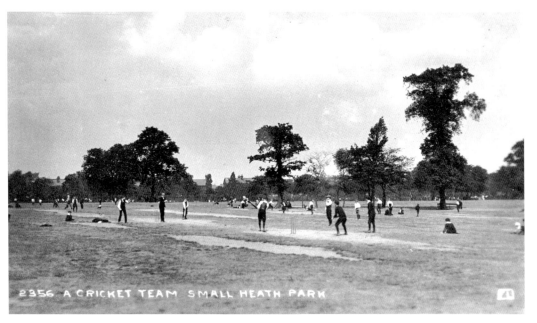

More cricket in the park; this time, Small Heath. No whites, just jackets off, and well-worn pitches. From the relatively few players in each group and the visible wooden stumps, it may be that some form of cricket practice is underway. The card is franked 12 Sept 1918 – no-one knew, but there were still two months to go of the First World War.

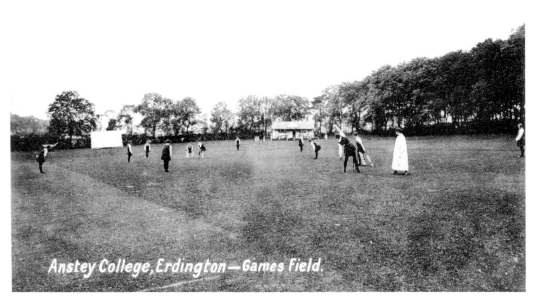

These ladies look keen and athletic, as indeed they would be, studying as they were to become gym teachers, the college being designed for that purpose. Founded by Rhoda Anstey in 1897, it moved from its original location to Yew Tree House, Chester Road in 1907, where it remained for many years.

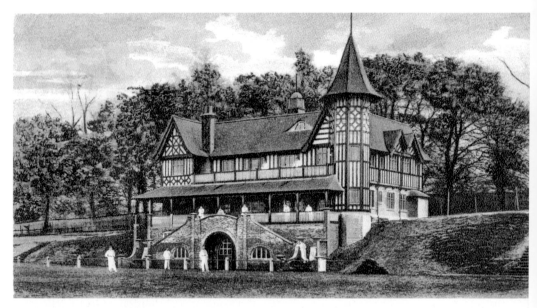

Built well before the 'In Remembrance Pavilion' appeared – the card is franked 1908 – this pavilion came to serve all manner of sports. The large grassed area adjacent to Cadbury's main factory was adequate for the staging of major athletic events.

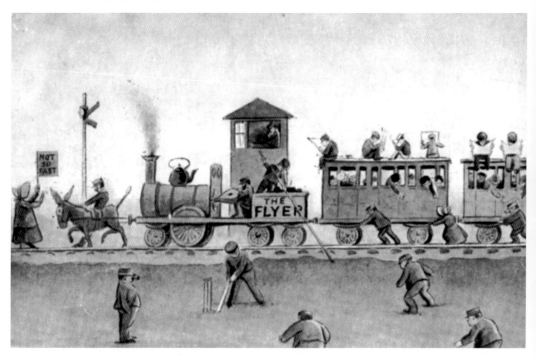

'Cynicus', artist and postcard publisher, no doubt used this design for a variety of named locations. The placid umpire, hands in pockets, smokes a pipe, as do some other railway personnel. Card franked 24 Sept 1907.

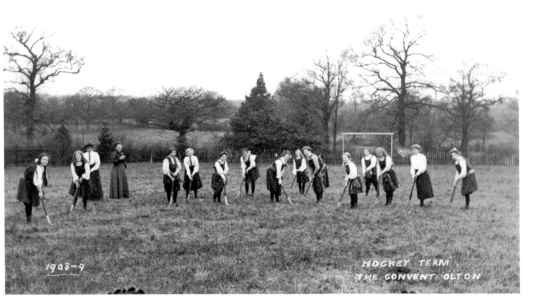

Hockey has a long history but it remains one of the few amateur games. The girls shown above seem to be at the start of the learning process – i.e. the manner in which to hold the hockey stick. The grass badly needs cutting. Really good hockey can only be played on a hard, flat surface.

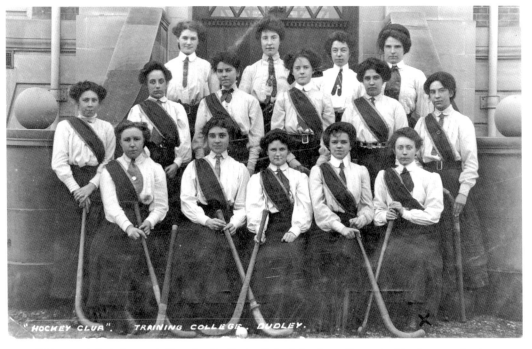

This team (albeit from neighbouring Dudley) will doubtless be well-practised in the way a hockey game is started – by the curious bully-off: 'two opponents strike each other's sticks three times and then go for the ball.' Presumably, the above team consists of the eleven players who are wearing a sash. Card franked 30 June 1911.

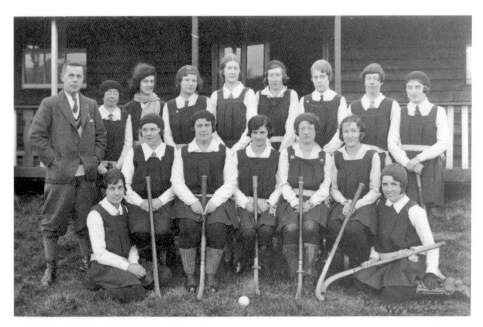

A team from Wylde Green. The gymslip, somewhat larger than the schoolgirl size, still holds sway. The solitary man is probably the coach or trainer, perhaps a hockey player himself. The men's and women's codes of hockey are similar and the two sexes can appear in one team. Inter-departmental hockey competitions, with men and women in each team, were sometimes arranged within larger firms.

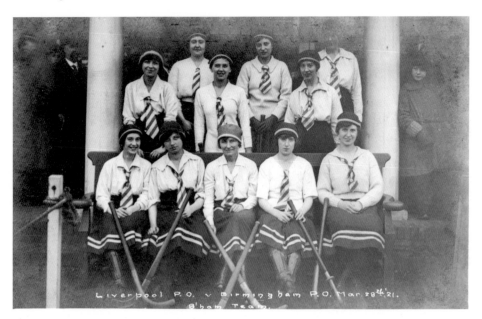

On the back of this card is written 'B'ham P. O. Hockey Team', P. O. meaning post office. These girls are smiling, so perhaps they won. The game was played on 28 April 1921. 'It's all in the wrist you know' – most likely, for the best players are very dexterous with the sticks.

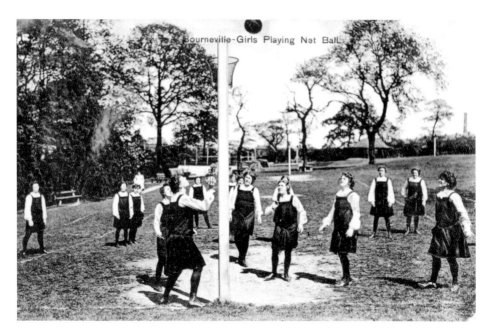

Another amateur ball game, historically netball is a British derivative of American basketball and became organised as a game for women in 1900/01. So, as the card above is franked 24 May 1907, netball, at Bournville and elsewhere, was still something of a novelty. Speed and accuracy of throw determine the quality of play.

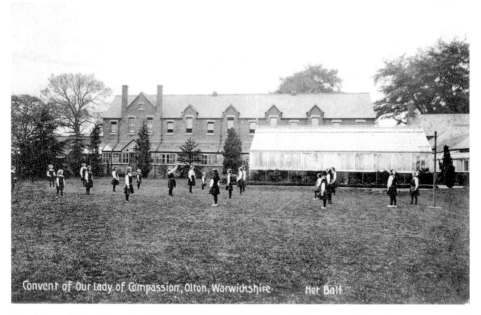

On this card's back is printed 'ENGLAND ½d STAMP', so it is pre-1918 that these convent girls are learning the new game. The instructress appears to be demonstrating how to hold the ball when preparing to throw. The net seems too high for these youngsters.

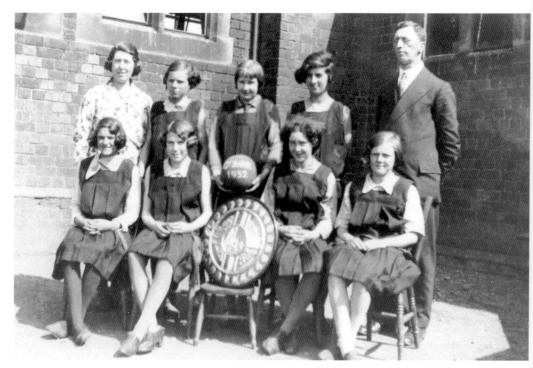

Doubtless a school team of winners, with a handsome shield to reward their success. Great Barr, 1932.

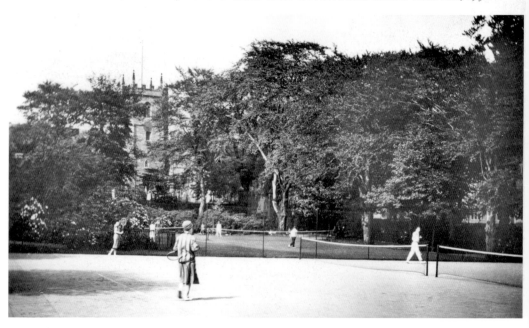

During the early decades of the last century, lawn tennis was widely regarded by many people as a game for toffs, snooty exclusive clubs and snobby people generally. Attitudes change, however, and public parks played an important part in bringing tennis nearer to Mr Everyman and Mrs Everywoman. Above is a pleasant corner of a park with the tower of the parish church peeping through the trees.

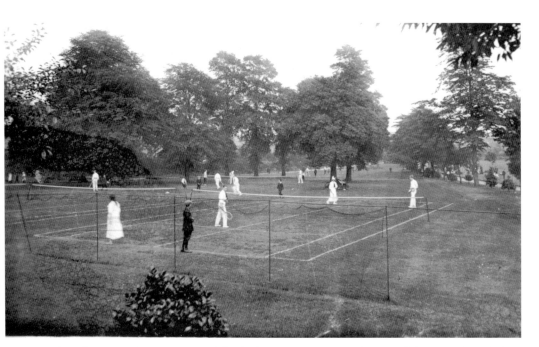

Another pleasant park scene on a card franked 13 August 1917. Probably a club event, when clothing other than whites would not be allowed.

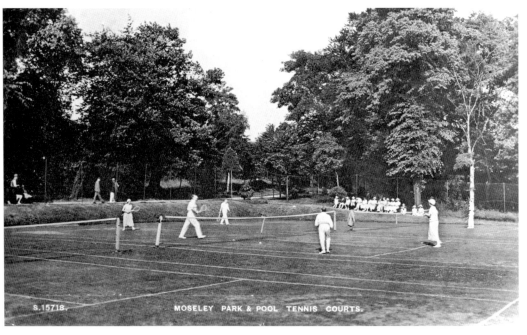

A game of mixed doubles is underway. Given the row of people in white who are watching, a club competition could be in progress. The card was written on 29 June 1929. During the 1930s, ructions occurred. Some fine players turned professional, including the great Fred Perry in 1936 – he had won the then-amateur men's singles at Wimbledon three years in a row. This proved to be a massive turning point in the game.

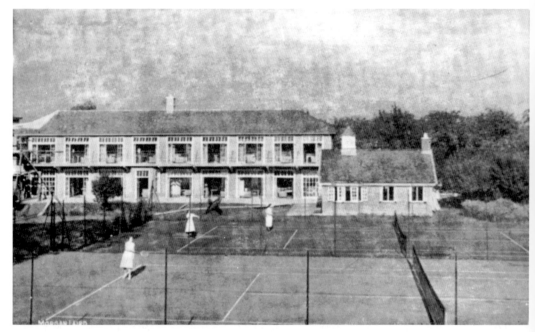

'I am fitting in very nicely. Have marked my room with a X.' So wrote the sender of this card on 25 January 1942. Conceivably, the tennis courts are for the recreation of the staff. This hospital developed out of a home on the Bristol Road, gifted by a member of the Cadbury family.

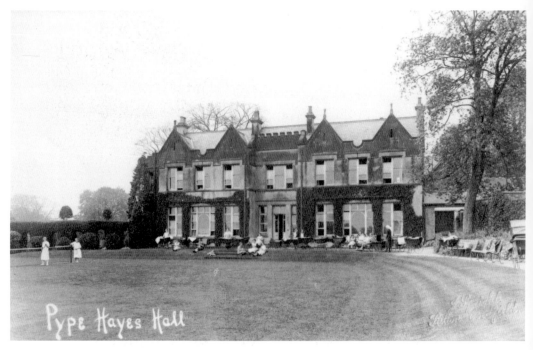

The date 1920 is scribbled on the back of this card. The hall dates back to the seventeenth century but was much altered over the years. Having been bought by Birmingham City Council in 1919, it became a nursery for children in care. Some of them may well be among the groups of spectators.

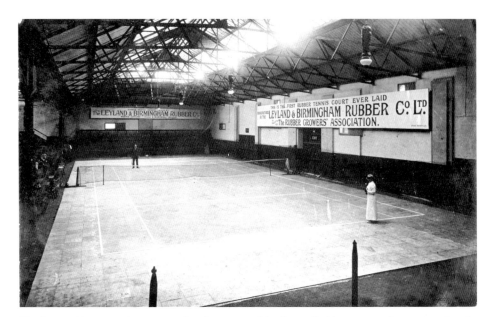

The lawn of lawn tennis, open to the elements and badly scuffed by wear and tear, can often be out of use. Other types of surface were, therefore, sought. No evidence of this indoor rubber floor is readily available, but there was probably a springy reaction from the tennis balls!

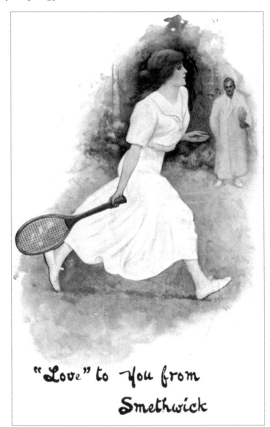

This card, franked 4 August 1917, serves as an illustration of the elegance that tennis can provide. Of course 'love' is used in a double sense, as it is part of the curious scoring system of the sport. And the second sense? Well beyond the scope of this book!

"Love" to You from Smethwick

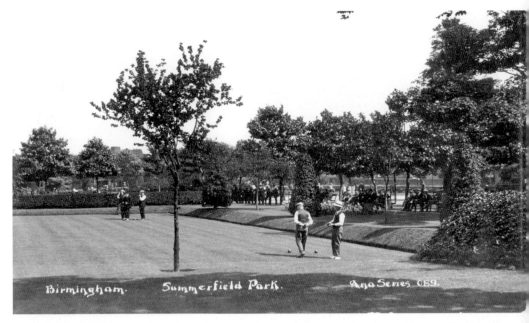

Birmingham. Summerfield Park. Ana Series 089.

It only needs a reference to the old sea dog Sir Francis Drake to remind us how old and enduring the game of bowls really is. Could it be the only ball game that relies on deliberate bias for both challenge and achievement? Summerfield Park principally served residents of Winson Green, Ladywood and neighbouring areas.

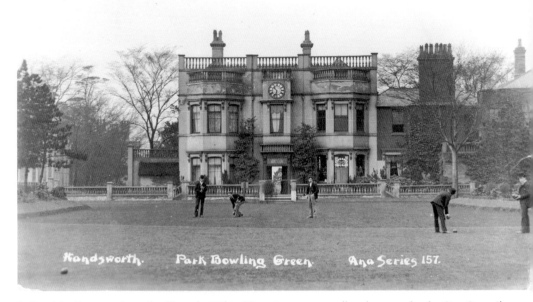

Handsworth. Park Bowling Green. Ana Series 157.

Built originally as a private dwelling, the 'White House', was eventually taken over by the City Council to serve partly as a refreshment room for the public. In the bottom right-hand window can be seen 'Cadbury's Chocolate'. Card franked 21 July 1932.

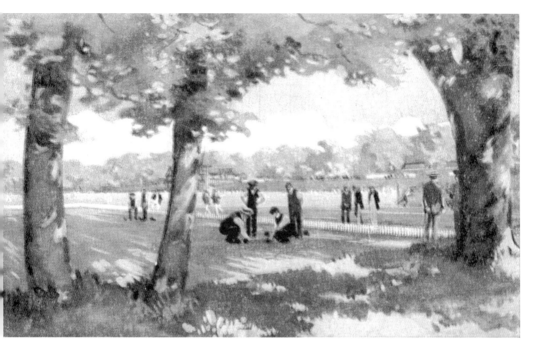

Two men crouch in opposite directions to take careful measurement of whose wood is 'on'. This bowling green forms but a small part of the Cadbury recreation ground. In the distance can be seen the red roof of the sports pavilion; a close-up view is shown on page 22.

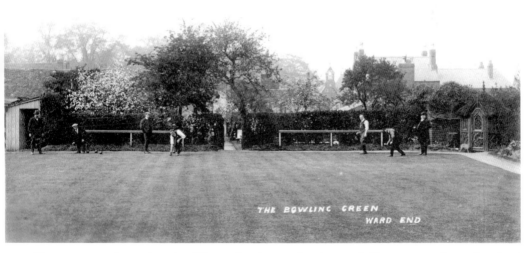

THE BOWLING GREEN
WARD END

Three men crouch, two in quite different directions, to bowl a wood. (See next page for explanation.) Left leg forward was favoured by right-handed bowlers. Bowling greens were numerous in Birmingham, often being attached to public houses. Card printed pre-1918.

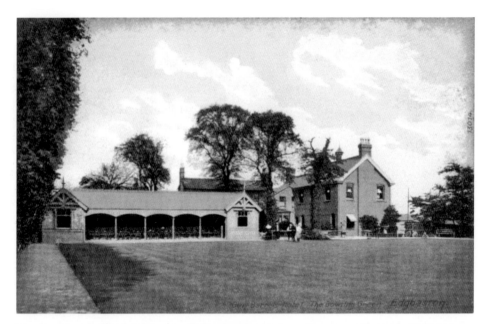

The Gun Barrels Hotel, Edgbaston, had room enough for a fine green. Birmingham's numerous clubs held to the crown green rules, under which the green would be raised in the centre and woods bowled in any direction. In the southern counties the green was flat and divided into adjacent strips; bowlers trundled up and down the strip on which they played. Card franked 1907.

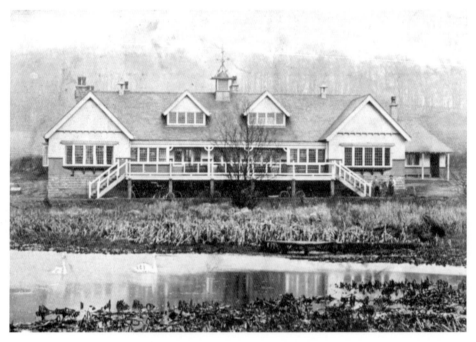

This card was posted on Boxing Day 1907. The clubhouse therefore, probably appears here as it did when opened in 1895. Handsworth Golf Club is in membership of the 1895 Club consisting of golf clubs that were formed in that year.

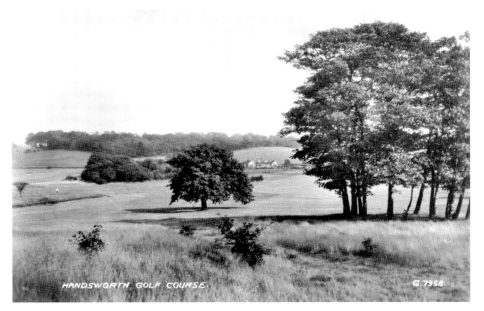

This card, probably from the 1920s, shows the pleasing countryside in which the club house is set. The building can be seen in the distance, between the two sets of trees. Although it has recently been handsomely refurbished, the spruced-up exterior shape remains very much as it was when first opened. Birmingham's city fathers took an interest in golf and provided municipal golf courses near certain parks. One example is Pype Hayes, where an eighteen-hole course was opened in 1933.

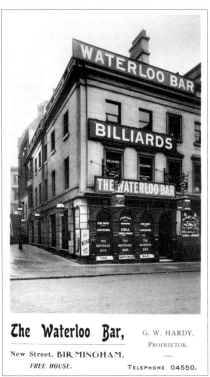

There may be many people who feel comfortable with a snooker cue but who remain uncertain about the game of billiards. There are only three balls for billiards: one red, one white and one white marked with a small black spot. Top professionals came to amass thousands of points at a break. Boring stuff to watch, the game was made much livelier at premises like the above, where there was a lower level of skill. Working Men's Clubs would usually have a table or two.

33

H. L. HART,
Sparkhill Harriers.

Public schools initiated cross-country running, those taking part being described as harriers. This type of race caught on and from the 1870s numerous running clubs were founded. Birmingham developed quite a number, some of which will be mentioned later. From the message on the card's back, the above harrier is displeased with the quality of the photograph.

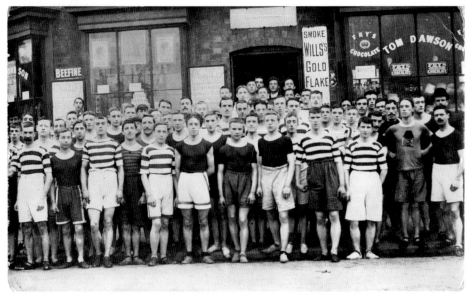

It is possibly a race of some consequence that is about to start. From the various strips, at least two clubs are taking part. It may be a cross-country run, or one that includes some road running. The location is thought to be a coffee house in Perry Barr. Almost certainly this is a pre-First World War photograph.

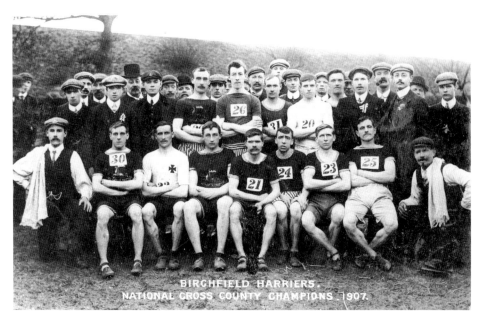

The first national championship was held in 1877 at Roehampton by the Thames 'Hare and Hounds' team. At the same venue, Birchfield Harriers had their first win in 1880. Their next wins came in 1886, 1887, 1888, 1891, 1892,1895 and 1903 – a very impressive record. Moseley won four consecutive victories 1881–84. This information has been gathered from the publication below.

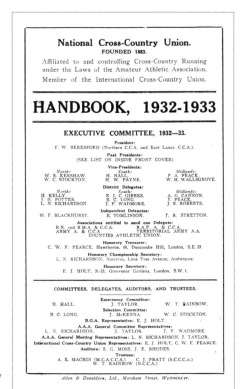

The front cover of the *National Cross-Country Union Handbook*, 1932/33.

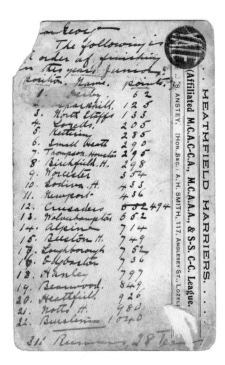

A conscientious official of Heathfield Harriers writes, 'Dear George, the following is [the] order of finishing in this year's Juniors' [Race], run on the Derby Racecourse, Kind regards R.H.S.' The card is franked 5 Feb 1907, delivered with a one penny stamp to Yale University, USA.

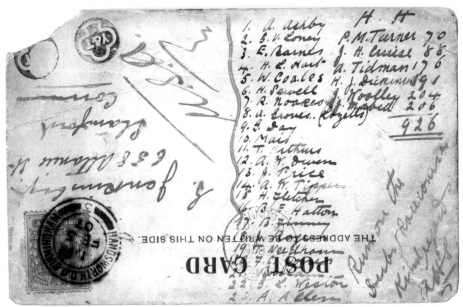

Taken together, the front and back of this card provide an insight into how winners, runners-up and also-rans were determined. This is pre-eminently a team race. Teams can enter more than six runners but only six can count, i.e. the first six runners to finish from, say, a team of ten. The first runner to finish scores 1 point, the fifteenth scores 15, the twenty-seventh scores 27, and so on. The winning team is that which totals the lowest number of points. Derby won with 62 points, Birchfield Harriers were eighth with 298 and Heathfield limped in at twentieth of twenty-two. Their six runners and score can also be seen.

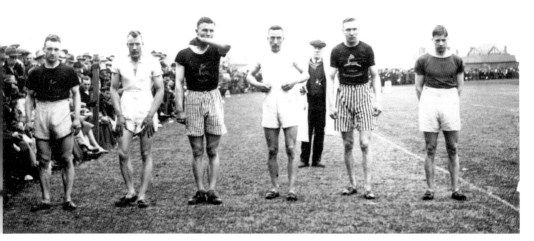

As well as cross-country running, many clubs included track and field events in their activities. Above is the line-up for the Midlands Quarter-mile Championship, 12 May 1928. From left to right, the runners are: P. Jeavons, A. W. Green, J. H. A. Hawkins (all Birchfield Harriers); S. Spencer (Sutton); H. Houghton (Birchfield); W. H. Spencer (Leicester). Houghton's vest carries Birchfield's emblem of the leaping deer and their motto, 'Fleet and Free'. The event was held on the sports ground of Metropolitan Works, Washwood Heath.

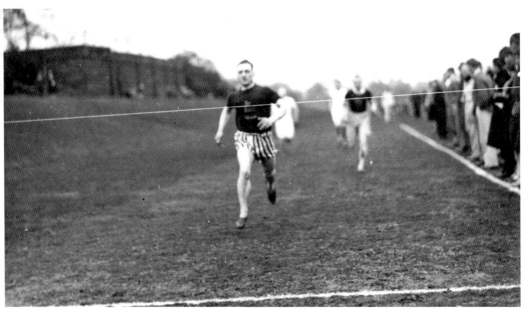

About to break the tape in a 440-yard race is P. Jeavons of Birchfield. This is a fixture between the Harriers and Birmingham University on 27 April 1929, held at the university ground on the Bristol Road.

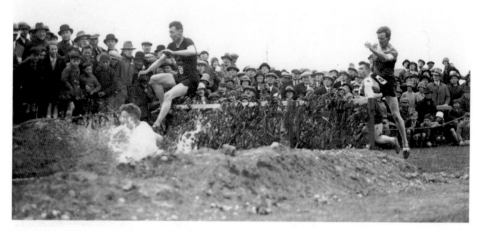

From the mid-1920s until the outbreak of war in September 1939, Eddie Webster was Birchfield Harrier's star runner in the steeplechase, middle-distance and long-distance events. He won national championships. The postcard above shows a moment from the two-mile steeplechase at the Midland Counties Championship, held on 15 June 1929.

SIXTH HEAT.

229—G. E. ROBINSON, Rover R.C. ,	55	Yards
16—G. MEREDITH, Crescent W.	72	"
343—F. W. PROSSER, Demon C.C.	75	"
.5—A. BENNETT, Crescent W.	8)	"
7—E. F. MIDDLETON, Rover R.C.	82	"
342—K. E. PROSSER, Demon C.C.	,	95	"
17—A. N. STANTON, Redditch R. & P.C.	100	"
First				Time		

4 100 YARDS SCHOOLBOYS' HANDICAP.

FINAL HEAT.

First Second Third Time

5 100 YARDS OPEN HANDICAP.

FINAL HEAT.

First Second Third Time

6 1,000 YARDS LADIES' HANDICAP.

(Under Women's A.A.A. Laws.)

Three Prizes.

379—MISS P. M. HALL, Birchfield H.	Scratch	
382—MISS G. M. WOODWOOLLY, Birchfield H.		10	Yards
389—MISS D. WHADCOAT, Birchfield H.		15	"
381—MISS A. BUSHNELL, Birchfield H.		35	"
388—MISS A. CARTMALE, Birchfield H.		50	"
380—MISS J. ROOKE, Birchfield H.		60	"
First		Second		Third	Time	

7 HALF-MILE OPEN CYCLE HANDICAP.

FINAL HEAT.

First Second Third Time

8 300 YARDS OPEN HANDICAP.

First Prize, value £4. Second Prize, value £2.

Third Prize, value £1.

First in each heat to compete in final.

FIRST HEAT.

81—G. PARKER, Birchfield H.	9	Yards
306—E. FISHER, Lozells H.	16½	"
149—W. F. BOARDMAN, Birchfield H.	18	"	
370—D. J. BAWCUTT, Birchfield H.	20	"	
186—J. PEARCE, Small Heath H.	22	"	
64—W. H. COX, Birchfield H.	23	"
27—R. N. GIBBS, Birchfield H.	24	"
29—F. C. SMITH, Sparkhill H.	26½	"
296—C. BUNN, Birchfield H.	27	"
First				Time		

Birchfield Harriers use BOVRIL in Training

(from *Birchfield Harriers Athletic & Cycling Sports*, April 19 1924) Is this an attempt by commerce to insinuate itself into an amateur sport?

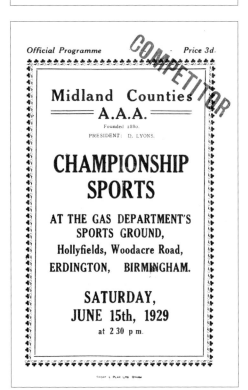

We have been much impressed with the value of "Bovril" as a quick restorative after severe physical exertion, and speaking for our club as a whole and individually we can safely say that nothing the men have taken has been so really useful and beneficial to them in training as your particular preparation.

In our opinion it is far superior to anything else of the kind, and we quite appreciate the full meaning of your phrase, "There is only one Bovril."

(Signed) THOMAS BIRCH, Chairman of the Committee.
W. W. ALEXANDER, Hon. Sec., Birchfield Harriers.

Given the testimonial (as warm as hot Bovril itself) at the foot of the card, and the fact that it is franked 10 January 1910, Bovril must have been supped for quite some time. There is no hint that it was drunk before a race, so possibly affecting the result. W. W. Alexander was a very able man and did a great deal to put this club on the map. The stadium built in Aldridge Road was named after him.

Official Programme — Price 3d.

COMPETITOR

Midland Counties
A.A.A.

Founded 1880.

PRESIDENT: D. LYONS.

CHAMPIONSHIP
SPORTS

AT THE GAS DEPARTMENT'S SPORTS GROUND,
Hollyfields, Woodacre Road,
ERDINGTON, BIRMINGHAM.

SATURDAY,
JUNE 15th, 1929
at 2 30 p.m.

(Cover, *Midland Counties A.A.A. Programme*, 1929) At this time, gas supply was a municipal utility, the gas showrooms being housed in the Council House.

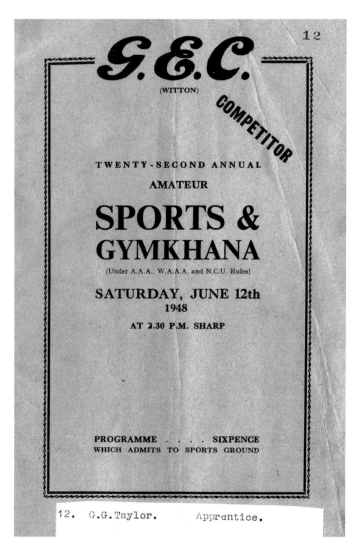

G.E.C.
(WITTON)

COMPETITOR

TWENTY-SECOND ANNUAL

AMATEUR

SPORTS & GYMKHANA
(Under A.A.A., W.A.A.A. and N.C.U. Rules)

SATURDAY, JUNE 12th
1948
AT 2.30 P.M. SHARP

PROGRAMME SIXPENCE
WHICH ADMITS TO SPORTS GROUND

12. G.G.Taylor. Apprentice.

(Ephemera GEC Sports and Gymkhana 1948.) Although this meeting is just post-war, the format is very much that of the 1930s – a mixed bag of activities for employees, their families and friends. With fifty racing events and various sideshows, there was much to do and see. Many of the running events were handicap races – lesser athletes being given yards starts. Some races had as many as six heats, so organisational skills were called for. A number of the events were of the family-fun type. These are listed below. Other major employers, like Lucas, staged similar annual meetings during the 1930s.

Event:
13 Men's Covent Garden
26 Boys' Sack Race
30 Tug-of-War
32 Ladies' Egg and Spoon Race
36 Couple's Race
38 Ladies' Three-Legged Race
44 Sew the Button Race

EVENT No. 38.—Ladies' Three-legged Race. Final.

THREE SETS PRIZES.

Pairing will be made on ground.

Final at 5.11.

20—Gill, M.	A.
21—Robb, J.	A.
34—Elsmore, N.	W.
35—Pinnock, N.	W.
36—Yarnall, J.	W.
37—Kilford, C.	W.
38—Edwards, M.	W.
39—Parkes, B.	W.
40—Roddy, W.	W.
41—Ford, J.	W.
42—Burford, L.	W.
43—Humpage, F.	W.
44—Shuker, A.	W.
45—Pickard, M.	W.
46—March, C.	A.
47—Francis, E.	A.
50—Bailey, M.	I.
51—Short, T.	I.
55—Markham, M.	I.
67—Humphreys, J.	S.
68—Reed, E.	S.
69—Cadman, M.	S.
70—Hill, B.	S.
75—Joyce, J.	S.
102—Osborne, J.	T.
103—Deegan, I.	T.
118—Griffiths, A.	X.
134—Walker, E.	D.O.
137—Butler, T.	D.O.
166—Wort, F.	B.
167—Rippard, N.	B.
168—Jullien, D.	B.
170—Stacey, M.	B.
171—Swinborn, C.	B.
172—Allen, J.	B.

First Pair Second Pair Third Pair

EVENT No. 36.—Couplet Race (Mixed Gymkhana). Final.

TWO SETS OF PRIZES.

Final at 5.3.

Entries received on the ground.

Instructions : Ladies and gentlemen to be lined up facing each other about 50 yards apart. A card will be attached to each of each competitor, bearing one-half of a couplet, e.g., the gent. "Romeo" and the lady "Juliet." On the word "GO" competitors to run to each other and find their partners. The first lady and gentleman to pair up and run hand-in-hand to the winning post correctly paired, to be winners.

First Pair Second Pair

PLEASE KEEP OFF THE TRACK

20

EVENT No. 44.—Sew the Button Race (Mixed Gymkhana). Final.

TWO SETS OF PRIZES.

Entries on the ground.

Final at 5.38.

Instructions : The ladies and gentlemen to be lined up, facing each other, about 50 yards apart. The gentlemen will be handed a needle and a piece of cotton, and the ladies a four-holed button. On the word "GO" the gentlemen must thread the needle, knotting the two ends of the cotton together and then run to any lady. The lady must then sew her button on to the gent's coat or shirt, the cotton to go through all four holes. The first lady and gentlemen to run to a finishing post, hand-in-hand, with the button sewn on correctly to be the winners.

EVENT No. 26.—Boys' Sack Race (under 17 years). Final.

ONE PRIZE.

Final at 4.18.

19—Hering, G.	..	I.	53—Suckling, A.	..	I.	109—Hughes, J.	..	X.

First

EVENT No. 13.—Men's Covent Garden Race. Heats.

THREE PRIZES.

Instructions : Competitors to carry four Baskets on head, same to be balanced with one hand only.

First in each Heat to compete in the Final.

Heat 1 at 3.1.

76—Winstanley, C.	F.P.
83—Powell, D.	S.
98—Phillips, T.	X.
105—Hook, H.	X.
115—Bowen, A.	X.
146—Bird, G.	A.A.
190—Webb, R.	D.O.
194—Scattergood, E.	X.
200—Ash, W.	X.

First

Heat 2 at 3.3.

19—Herring, G.	I.
57—Remedios, A.	A.A.
77—Waldron, H.	F.P.
99—O'Sullivan, M.	R.
106—Stanier, E.	X.
148—Granger, D.	A.A.
192—Walls, G.	D.O.
195—Harrington, A.	X.
201—Gill, R.	X.

First

Heat 3 at 3.5.

64—Reece, J.	A.A.
78—Greenhouse, H.	F.P.
89—Smith, E.	I.
100—Fielding, K.	R.
107—Hession, S.	X.
150—John, J.	A.A.
193—Gittings, G.	D.O.
196—Harris, F.	X.
204—Williams, D.	X.

First

Heat 4 at 3.7.

22—Weaver, J.	F.
80—Day, P.	F.P.
93—Kerr, H.	I.
109—Hughes, J.	X.
128—Wills, A.	E.
141—Johnston, T.	A.A.
152—Bamfield, B.	A.A.
197—Clayton, T.	X.
205—Sturch, W.	X.

First

PLEASE KEEP OFF THE TRACK

11

Covent Garden (London) – Market porters were famous for carrying a pile of round wicker baskets on their nappers. The race is based on that practice, no doubt accompanied by amusement and much laughter.

EVENT No. 32.—Ladies' Egg and Spoon Race. Heats.

THREE PRIZES.

First two in each Heat to compete in Final.

Heat 1 at 4.47.

20—Gill, M.	A.
34—Elsmore, N.	W.
38—Edwards, M.	W.
42—Burford, L.	W.
50—Bailey, M.	I.
70—Hill, B.	S.
119—Ridley, K.	X.
137—Butler, T.	D.O.
166—Wort, F.	B.
170—Stacey, M.	B.

First Second

Heat 2 at 4.48.

21—Robb, J.	A.
35—Pinnock, N.	W.
39—Parkes, B.	W.
43—Humpage, F.	W.
51—Shortt, T.	I.
67—Humphreys, J.	S.
75—Joyce, J.	S.
120—Isley, D.	X.
167—Rippard, N.	B.
171 Swinborne, C.	B.

First Second

Heat 3 at 4.49.

36—Yarnall, J.	W.
40—Roddy, W.	W.
44—Shuker, A.	W.
46—March, C.	A.
55—Reed, M.	I.
68—Reed, E.	S.
102—Osborne, J.	T.
121—Slack, J.	X.
168—Jullien, D.	B.
172—Allen, J.	B.

First Second

Heat 4 at 4.50.

13—Shotton, M.	T.
37—Kilford, C.	W.
41—Ford, E.	W.
45—Pickard, M.	W.
47—Francis, E.	A.
69—Cadman, M.	S.
103—Deegan, I.	T.
122—Cook, D.	X.
134—Walker, E.	D.O.
169—Harte, S.	B.

First Second

Final at 4.51.

EVENT No. 30.—Departmental Tug-of-War. Final.

for the
" M. J. and A. H. RAILING " CHALLENGE CUP.

TWO SETS OF PRIZES. **Final at 4.30.**

1st. Round.	2nd. Round.	Semi-final.	Final.	Winners.
W.M.I.				
Apprentices	Apprentices			
Bye	Foundry & Pattern	Fdy. & Patt.		
Bye	Engineering & Standard		Fdy. & Patt.	
Bye	Fan, D.A. & Govt. Shop	Eng. & Std.		
Bye	Switch Works			
Bye	Transformer	Switch Works		
Bye	Drawing Offices		Drawing Offices	
Bye	Stores & Estates	Drawing Offices		

TIME SCHEDULE OF EVENTS

Event No.	Time	Heat or Final	Event	Page
1	2.30	Final.	Boys' 80 yards Flat Handicap (under 17)	10
2	2.31	Final.	Girls' 80 yards Flat Handicap (under 17)	10
3	2.32	Heats.	Veterans' 80 yards Flat Handicap (50 years and over)	10
4	2.34	Heats	Men's 100 yards Flat Handicap	10
5	2.42	Heats.	Ladies' 100 yards Flat Handicap	12
6	2.44	Heats.	Veterans' 100 yards Flat Handicap (35 to 49 years)	12
7	2.48	Final.	Men's One Mile Walking Handicap	12
8	2.53	Heats.	Men's 440 yards Flat Handicap	12
9	2.57	Final.	Veterans' 80 yards Flat Handicap (50 years and over)	13
10	2.58	Final.	Men's 100 yards Flat Handicap	13
11	2.59	Final.	Ladies' 100 yards Flat Handicap	13
12	3.0	Final.	Veterans' 100 yards Flat Handicap (35 to 49 years)	13
13	3.1	Heats	Men's Covent Garden Race	14
14	3.13	Final	Ladies' 440 yards Walking Handicap	14
15	3.15	Final	Men's 880 yards Cycle Handicap	14
16	3.19	Final	Men's ½-Mile Departmental Relay	14
17	3.21	Final	Ladies' 440 yards Departmental Relay	15
18	3.26	Final	Putting the Shot	15
19	3.30	Final	Children's Races	15
20	3.30	Final.	Beauty Competition	15
21	3.40	Final.	Men's 220 yards Flat Handicap	16
22	3.55	Heats.	Ladies' 220 yards Flat Handicap	16
23	4.2	Heats	Senior Wranglers' Race	17
24	4.5	Final.	Men's 880 yards Flat Handicap	17
25	4.15	Final.	Boys' Sack Race	17
26	4.18	Final.	Men's 220 yards Flat Handicap	17
27	4.20	Final.	Men's One-Mile Cycle Handicap	17
28	4.21	Heats.	Men's High Jump	18
29	4.25	Final.	Departmental Tug-of-War	18
30	4.30	Final.	Men's 440 yards Flat Handicap	18
31	4.39	Heats	Ladies' Egg and Spoon Race	19
32	4.47	Heats.	Men's One-Mile Cycle Handicap	19
33	4.51	Final.	Men's 120 yards Low Hurdles	20
34	4.53	Final.	Couplet Race (Mixed Gymkhana)	20
35	4.56	Heats.	Foremen's 440 yards Invitation Walking Handicap	20
36	5.3	Final.	Ladies' Three-legged Race	21
37	5.8	Final.	Men's 440 yards Flat Handicap	21
38	5.11	Final.	" Devil Take the Hindmost " Cycle Race	21
39	5.14	Final.	Ladies' 100 yards Skipping Handicap	22
40	5.18	Heats.	Fire Brigade Hydrant Drill (1-Man)	22
41	5.27	Final.	Men's Obstacle Race	22
42	5.30	Final.	Sew the Button Race (Mixed Gymkhana)	23
43	5.35	Final.	Men's 120 yards Low Hurdles	23
44	5.38	Final.	Ladies' 100 yards Skipping Handicap	23
45	5.43	2nd R'd	Fire Brigade Hydrant Drill (4-Men)	24
46	5.45	Final.	Men's One-Mile Flat Handicap	24
47	5.46	Final.	" Devil Take the Hindmost " Cycle Race	24
48	5.51	Final.	Men's 120 yards Low Hurdles	24
49	5.56	Final.		24
50	5.59	Final.		24
	6.0		Presentation of Prizes	24

9

41

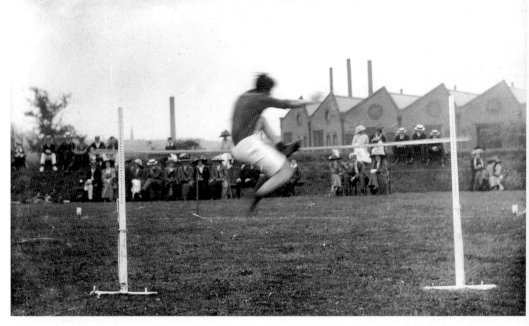

An industrial backdrop for a field event at what is thought to be the annual sports day at Saltley Teachers' Training College, *c.* 1912. There appears to be a fine display of ladies' hats on the touchline. Something other than the jumper seems to have attracted the attention of the three chaps in boaters –the two ladies in hats nearby, perhaps?

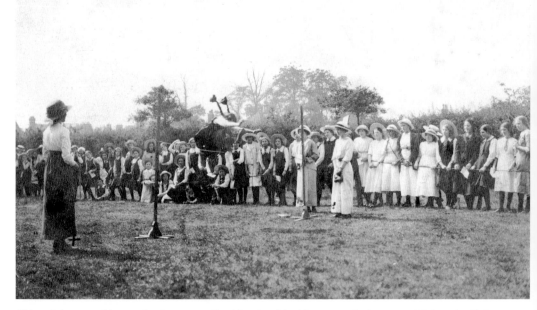

Although hampered by a voluminous gymslip skirt, the girl with outstretched arms and flying pigtails has made a splendid leap. The card is franked Birmingham 26 July 1914 and its sender writes, 'This is a picture of our school sports x this is Miss Parker the one who has my class + this is Miss Gettings ... Constance.'

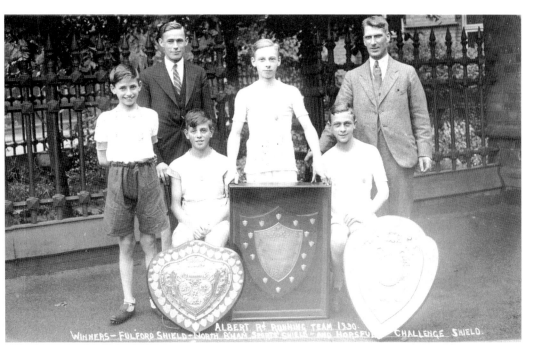

Clearly, this is an eminently successful school boy team of runners. The caption refers to Albert Road as the school and 'North B'ham Shield', which suggest that this Albert Road is located in Aston.

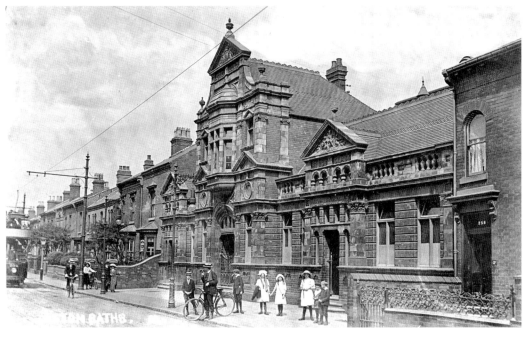

True to its motto, 'Forward', Birmingham introduced its first public baths in 1851, in Kent Street. These fine Victorian baths, shown above, opened in 1892. Two swimming pools were provided and a number of slipper baths, as few homes at the time possessed a bathroom. This card is franked 9 August 1911.

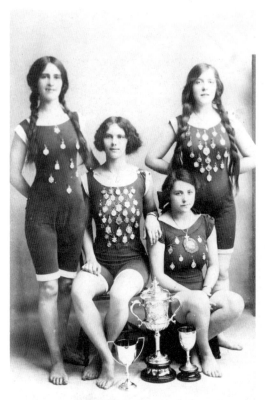

Such pools as those mentioned on the previous page quickly led to the formation of swimming clubs. In turn, this led to swimming competitions of various kinds. The girls above are proud to sport their swimming trophies as members of Aston Swimming Club. Photograph *c.* 1908.

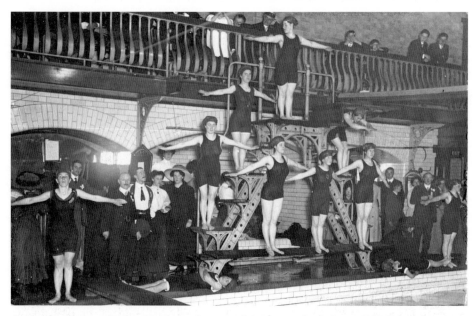

At the Grove Lane Baths, Handsworth, opened in 1907, the ladies' swimming club put on displays from time to time, including an early form of synchronised swimming. One of the ten girls shown on the card seems a little too eager to take the plunge.

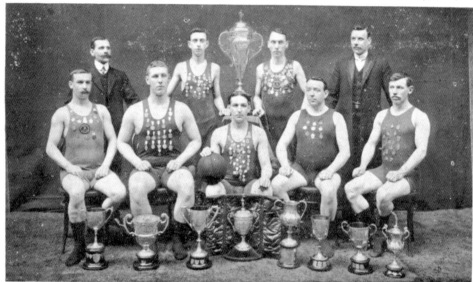

Aston male swimmers were just as ready as the ladies to display medals and cups. Water polo could be a bruising sport but, from their appearance, this team has a fair quota of apparent bruisers. For some reason, the title of 'professor' was conferred on instructors.

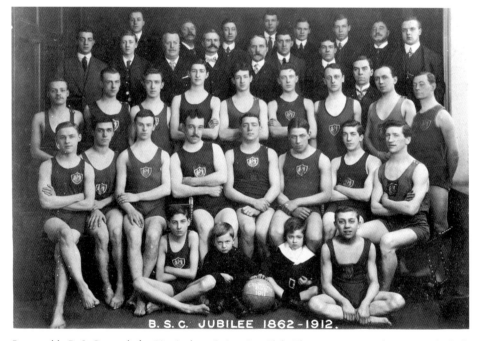

B. S. C. JUBILEE 1862-1912.

Presumably B. S. C. stands for Birmingham Swimming Club. The year 1911 can be seen on the ball.

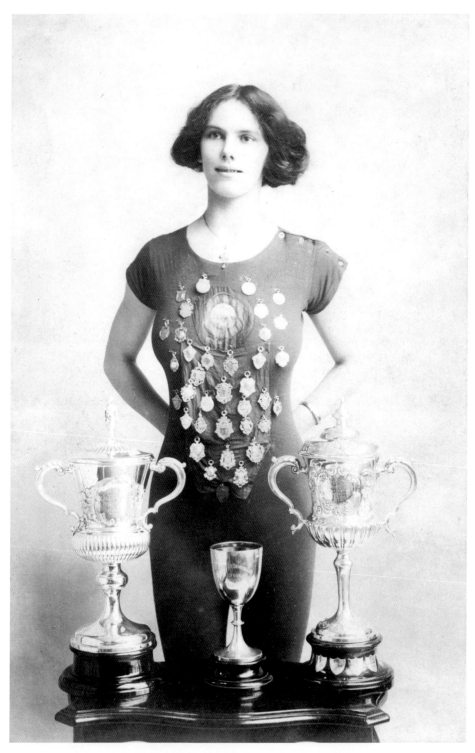

Far more likely than not, this is the champion swimmer who is sitting second from the left on page 44. At the risk of appearing personal, that is a very determined chin!

During the latter half of the nineteenth century, the Nordic countries and Germany gave the lead in Europe for the development of gymnastics. In Birmingham, various clubs and associations were founded. Competition successes were often recorded in photographic studios. The card above illustrates the standard kit of the day. On the back of the card is written, in a clear hand, 'J Haywood, 92 Rose Villas, Bennetts Road, Saltley.'

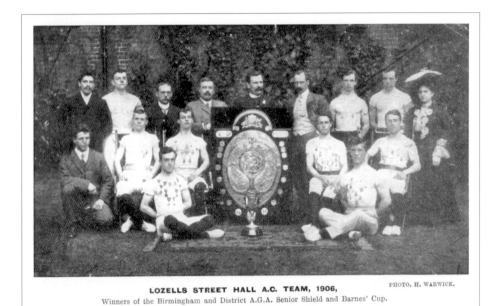

LOZELLS STREET HALL A.C. TEAM, 1906,

PHOTO, H. WARWICK.

Winners of the Birmingham and District A.G.A. Senior Shield and Barnes' Cup.

Clearly, a highly successful club. The card carries this message: 'I have your Cup and Medal at my house, & should be glad if you would arrange to call for it this week for certain...' It is addressed to Mr J. Wyld, 13 Alston Street, Ladywood, and franked 14 May 1907.

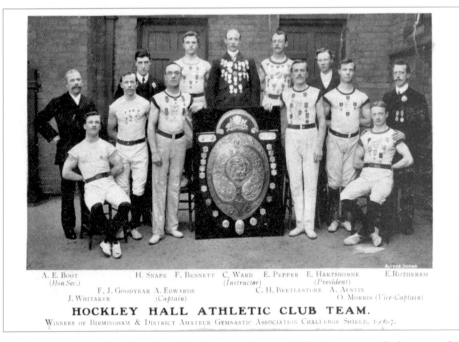

A. E. BOOT H. SNAPE F. BENNETT C. WARD E. PEPPER E. HARTSHORNE E. ROTHERAM
(Hon.Sec.) (Instructor) (President)
 F. J. GOODYEAR A. EDWARDS C. H. BEETLESTONE A. AUSTIN
J. WHITAKER (Captain) O. MORRIS (Vice-Captain)

HOCKLEY HALL ATHLETIC CLUB TEAM.

Winners of Birmingham & District Amateur Gymnastic Association Challenge Shield, 1906-7.

Another successful suburb-based club. Judging by the two shields, (see top card) they were the winners in 1907 of the same competition? Watch out for C. Ward, instructor, who will appear again on some of the following cards.

48

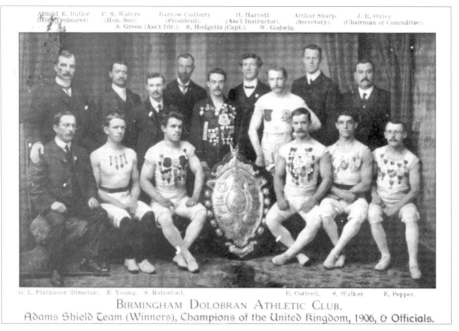

Arnold E. Butler P. S. Waters Barrow Cadbury H. Harvett Arthur Sharp J. K. Oxley
(Hon Treasurer) (Hon. Sec). (President). (Ass't Instructor). (Secretary). (Chairman of Committee).
S. Green (Ass't Dir.). S. Hodgetts (Capt.). W. Godwin.

G. L. Platnauer (Director). E. Young. S. Rainsford. B. Cottrell, S. Walker E. Pepper.

BIRMINGHAM DOLOBRAN ATHLETIC CLUB.
Adams Shield Team (Winners), Champions of the United Kingdom, 1906, & Officials.

National winners 1906 – a splendid achievement! A member of the Cadbury family stands in the back row, Barrow Cadbury (president). The postcard is franked 5 April 1909. While 'back room boys' don't usually appear in such numbers, this was an exceptional triumph and one to be shared.

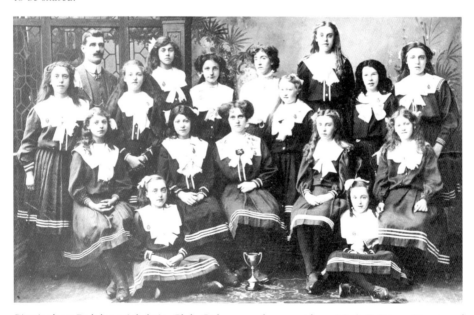

Birmingham Dolobran Atheletics Club. Only one male present here, Mr A. E. Peters, Director of Physical Exercises. A. W. Cooke is the lady pianist – fourth from the right, back. Seated at the centre of the front row is 'The Instructress of the Team'. The cup itself seems a little too junior in its size for the 'Birmingham and District AGA (Amateur Gymnastics Association) Juniors' Cup', won here in 1909/10.

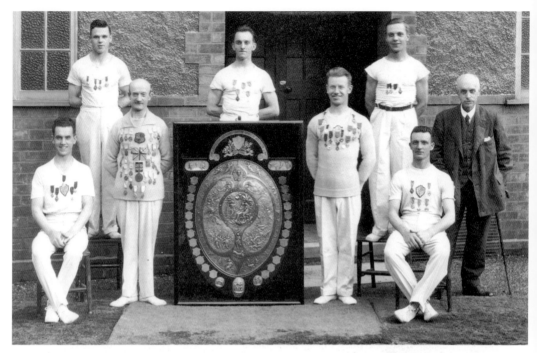

Some years later, this shield seems to be the same as that shown in the Lozells and Hockley photographs (page 48), but by now many more medals are to be seen on either side. The veteran, right, is probably a well-respected official and the balding man, left, is surely Mr Ward, instructor.

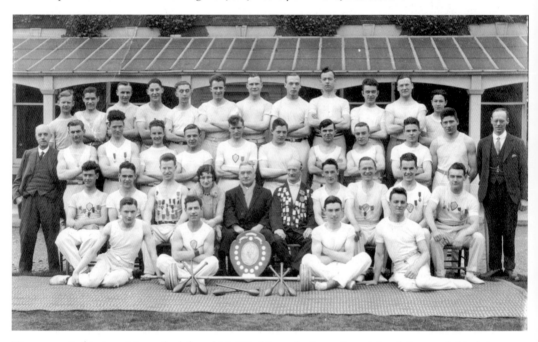

Now our suited 'veteran' is on the left and Mr Ward is to the immediate right of the man behind the shield. To his right sits a young lady – a secretary perhaps, or leader of a ladies' gymnasts club? Just in front of the trophy are neat groupings of wooden Indian clubs, used in pairs to exercise the arms.

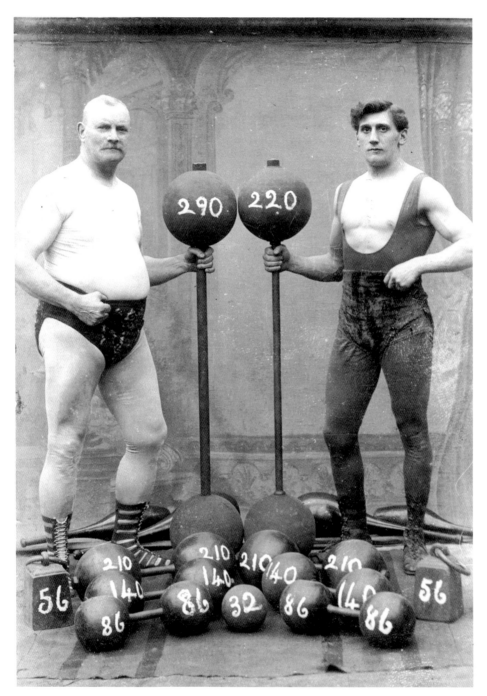

The story runs that two Handsworth friends (from Heathfield and Trinity Roads) decided, for a bit of a lark perhaps, to demonstrate their weightlifting abilities and their physique. The weights of the barbells were doubtless expressed in pounds. All the lesser weights seem to be for one-handed lifts, as the rods of the barbells are short. Did these 'hunks' actually lift those weights or simply raise them to the upright position? We shall never know. A small contribution to the history of the leotard (right)?

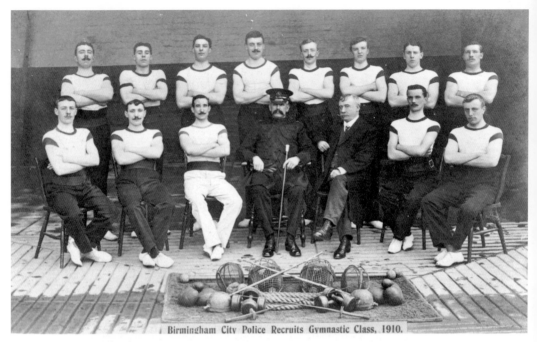

Birmingham City Police Recruits Gymnastic Class, 1910.

A well turned-out group of police recruits. From the apparatus neatly set out on the mat, fencing and weight lifting were included in the training programme.

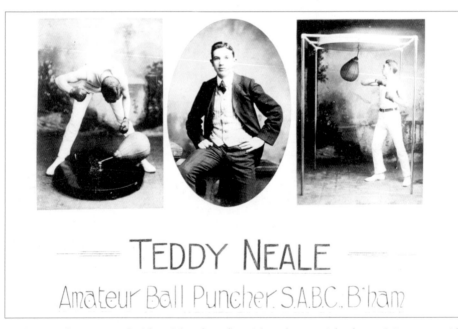

TEDDY NEALE

Amateur Ball Puncher S.A.B.C. B'ham

Boxing was also concerned with weights, from flyweight to heavyweight classes. It is a sport with a long history and two codes, amateur and professional. The above card seems to be promotional, but for what purpose? No address is given. Teddy looks to be a dapper young man and probably belonged to those who held boxing to be 'the noble art of self-defence'.

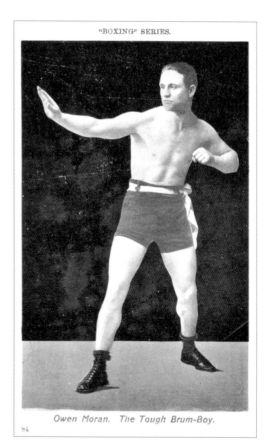

Nicknamed 'The Fearless', this boxer was born in Birmingham in 1884. Tough he certainly was, for he held the world bantamweight title for a time. He retired from the ring in 1916, but he continued to take an active interest in the sport in Birmingham. (To nip a possible misconception in the bud, bareknuckle fighting had long been outlawed, but the pose is perhaps more striking with the gloves off.)

Owen Moran. The Tough Brum-Boy.

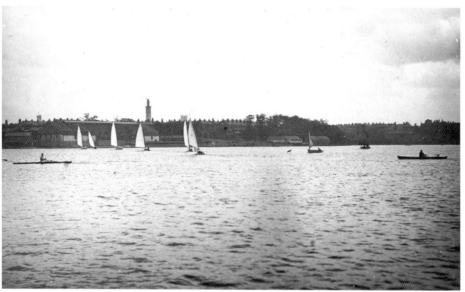

Unlike many major cities, Birmingham was not built by a river that assisted its trading, manufacturing or water sports. Fortunately, Edgbaston Reservoir was large enough to sustain sailing and rowing. The above card was franked 29 September 1913.

MIDLAND
Sailing Club,
1922.

FIXTURES.

EDGBASTON RESERVOIR

Rule Alterations, 1922.
Class.

No. 23a.—A restricted Dinghy Class to be Established in the Club, all new boats to the Club in future to come within the following re-restrictions.

Class : Dinghy.

Max. length 14ft.

Max. Sail area.

150 sq. ft.

Rule 11 (F) addition.

For Active Lady Member, Subs. £1 1s. Entrance Fee 10/6

An " Active Member " is a Boat Owner or Member entitled to take the helm in a Race.

Any " Non-Active Member " take-ing the helm in a race becomes *ipso facto* an Active Member.

(Ephemera – Midland Sailing Club.)

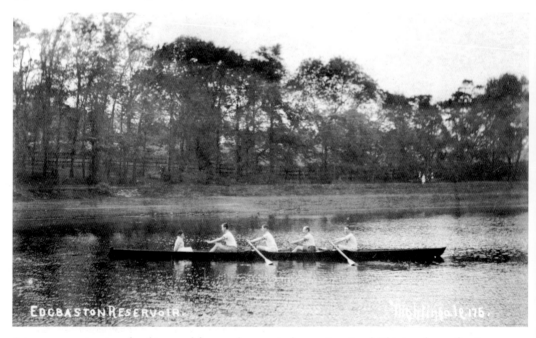

EDGBASTON RESERVOIR.

A tense moment or two for this coxed four as they await the starting signal. This is a form of serious, competitive racing. Postcard franked 9 December 1908.

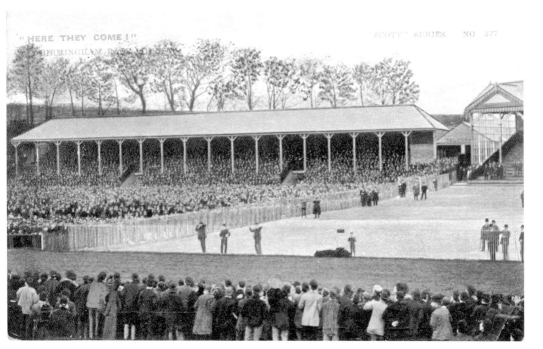

The city's Bromford Bridge Racecourse experienced, like many punters, a chequered career. Opened in 1894, in 1912 it received permission to stage eight days' flat racing and eight days' steeplechasing in the coming season. The postcard is franked 3 February 1906. The sender writes, 'Just a small crowd, expect to see just as many this afternoon.' Obviously, the situation had been very different some time earlier. In May 1914 the grandstand was burned down by suffragettes. To increase the number of racegoers, a railway station was built at Bromford Bridge, open only on race days. The last race meeting was held in 1965.

A Bamforth 'Comic' series card, franked 1934.

There were, of course, different views from those of the 'barrow boy'.

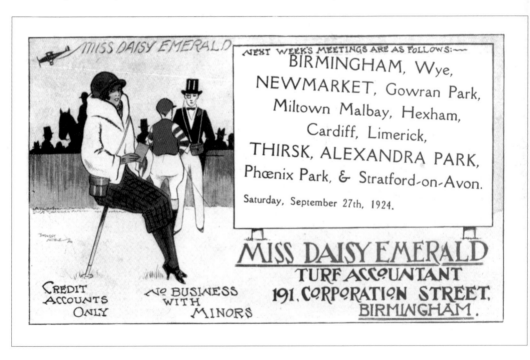

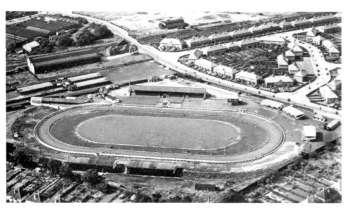

During the inter-war years both greyhound racing and speedway racing became very popular. Here is a fine track built for both sports in south Birmingham. Similar facilities were provided for the north, at Perry Barr.

Right: Ephemera – Greyhounds, Hall Green newspaper excerpt.

JACK PARKER WALLY LLOYD

Imported with great success from Australia, speedway (dirt track) increased in popularity between the wars. Teams of daredevils were to be found in many towns, including Birmingham. Although Belle Vue in Manchester and Wembley and West Ham in London enjoyed greater success, Perry Barr and Hall Green provided plenty of cinder-flying excitement. (Jack Parker: Hall Green; Wally Lloyd: Perry Barr.)

15 JUNE, 1931

CHANCE FOR NEW-COMER.

Sans Select at Hall Green To-night.

By MAJOR X.

A programme of engrossing interest is arranged for Hall Green this evening, and the recent high standard of racing at this track should be maintained.

Sans Select, a new dog, who has been performing well in trials, should win the sixth race.

First Race (500 yards).—Woodthorpe Surprise, Mullinahone Flier Captain Fury, Roving Paddy, Hypocrite.
Selection—HYPOCRITE.

Second Race (260 yards sprint race).—Equinox, Worsted Whiskey, Na Boc Oms, Roving Showman, Multytown.
Selection—WORSTED WHISKEY.

Third Race (500 yards hurdles handicap).—Sans Teddy (scr.). Woodlands Syanat (2½ yards), Lisband Earl (5), Air News (7½).
Selection—SANS TEDDY.

Fourth Race (500 yards handicap).—Malbay Hope (scr.), Sans Saucy (2½ yards), Black Donna (5), Scarlet Arrow (7½), Real Posh (10).
Selection—REAL POSH.

Fifth Race (500 yards hurdles).—Round Tub, Silver Ivy, Modern Style, British Lawyer.
Selection—BRITISH LAWYER.

Sixth Race (500 yards).—Sans Select (late Widemarsh), Bubbling Laughter, Greenhills, Louis Meyers, Nipper Simms.
Selection—SANS SELECT.

Seventh Race (500 yards).—Vineyard Lad, Sans Billy, Village Guard, Not Hurried, Aclare Arrow.
Selection—VILLAGE GUARD.

Perry Barr.

First Race (525 yards flat).—Milton Muse, Wilsaddle, Tommy Tucker, Renroh Vale, Onaway II.
Selection—TOMMY TUCKER.

Second Race (525 yards flat).—Neidin's Jostler, Holman Boy, Bandon Jack, Dick, Ditton Hero.
Selection—HOLMAN BOY.

Third Race (525 yards hurdle).—Bremen, Boaster, Carrignaloy, Nippy John.
Selection—NIPPY JOHN.

Fourth Race (525 yards flat).—Paint Pot, Fawnaway, Ramadan, Linda, Urmstone Mebbies.
Selection—FAWNAWAY.

Fifth Race (open hurdle race).—Final.

Sixth Race (525 yards flat).—Patsy's Darling, Shilloh Border, Why Blush, Cotswold Fibert, Bill's Babette.
Selection—PATSY'S DARLING.

Seventh Race (525 yards flat).—Mount Mill, Dancing Dick, Dark Nancy, Martonia, Wild Girl.
Selection—DANCING DICK.

Wolverhampton.

First Race (525 yards flat).—Kilmogue Lad, Star of Destiny, Music Street, Grove Wooer, Division.
Selection—MUSIC STREET.

Second Race (500 yards flat handicap).—Big Wonder Boy (scratch), Island Kitty (2yds.), Teaser of Torridge (6), Tea Shop (10), Lonely Simon (14).
Selection—BIG WONDER BOY.

Third Race (500 yards hurdles handicap).—Rattling Jasper (scratch), Caterer (2yds.), Kellosera Boy (8), Belcamp Boy (10).
Selection—BELCAMP BOY.

Fourth Race (525 yards flat).—Derryhan Guard, Great Challenge, Inver Garry, Post Haste.
Selection—GREAT CHALLENGE.

Fifth Race (500 yards flat handicap).—Reviser (scratch), Harp String (2yds.), Occasional Light (4), Honest June (8), Truthful Charger (14).
Selection—OCCASIONAL LIGHT.

Sixth Race (500 yards flat handicap).—White Bait (scratch), Venger (4yds.), David's Gift (8), Magnet (10), Brave Band (12).
Selection—WHITE BAIT.

Seventh Race (250 yards flat handicap).—Lackabawn Boy (scratch), Canterbury Bell (4yds.), Bits of Gold (8), Coinage (10), Kirwan's Hill (14).
Selection—LACKABAWN BOY.

Eighth Race (290 yards flat).—Jack Drummond, Lone Night, Dark Boy, Riversdale Hero, Blue Pennant.
Selection—JACK DRUMMOND.

Coventry.
(All races over 500 yards.)

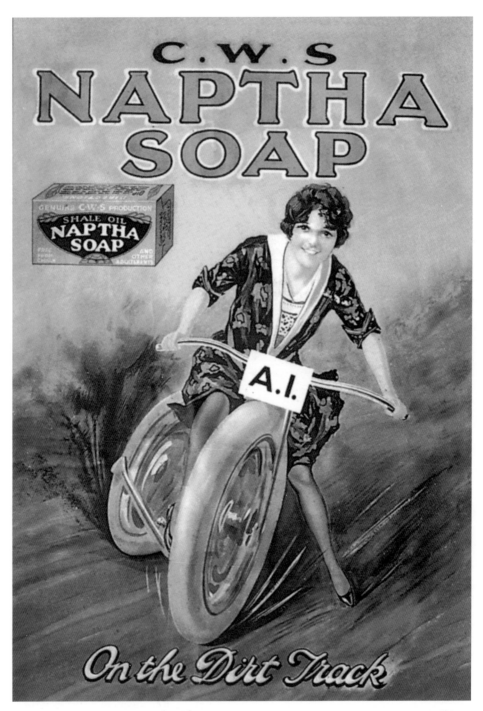

An example of adroit advertising. The registration No. A1 carries a message. Historically A1 meant a first-class vessel on Lloyd's Register of Shipping. Passed A1 into the Army meant the recruit was in the fittest class, with C3 being reserved for the weaklings.

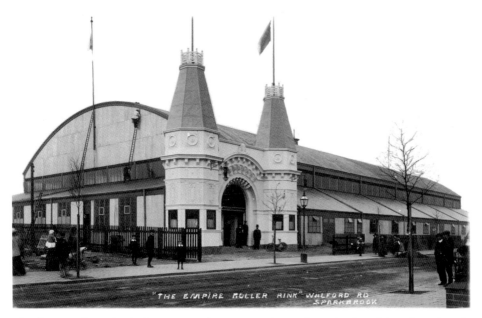

The above card was franked at Camp Hill in 1910 and posted to Liège in Belgium, to 67 Rue de Joie (Street of Joy). This relatively new building echoed to the sound of joy bound up with the noisy clatter of roller skating, the latest American craze that had caught on.

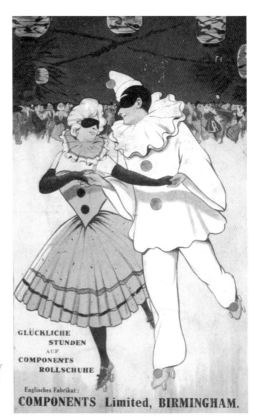

Roller skating was also popular in North Europe. The German wording reads, 'Happy Hours on Component's Roller Skates, made in England'. They were in fact made by a Brummagem firm.

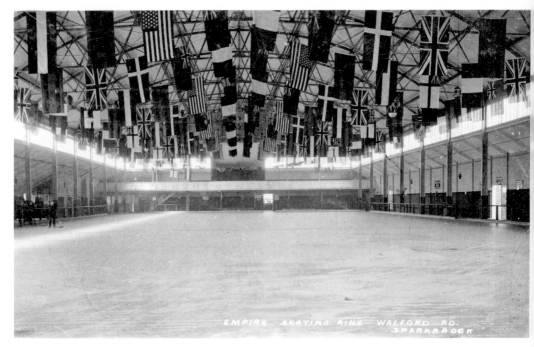

To quote Hamlet: 'Look here upon this picture, and on this'. Above, we have a silent, empty room with seemingly every flag under the sun bringing colour and interest; and below appears the same room, with the same flags, beginning to come alive. The rink staff, twenty of them, are getting ready for the skating customers. This card was also franked in 1910. The sender writes, 'We are just off to look at Rink which is quite near...'

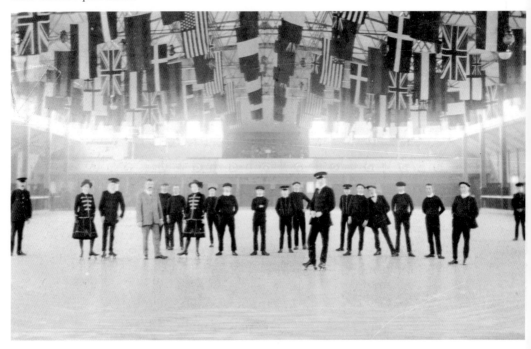

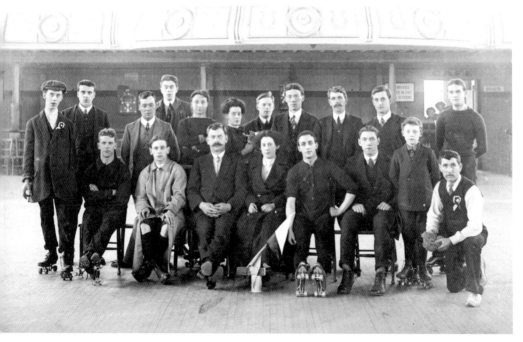

This is probably also the Empire Rink, with the staff about to put on their work clothes and literally 'get their skates on.' Two nosey people are having a peep in from the open doorway.

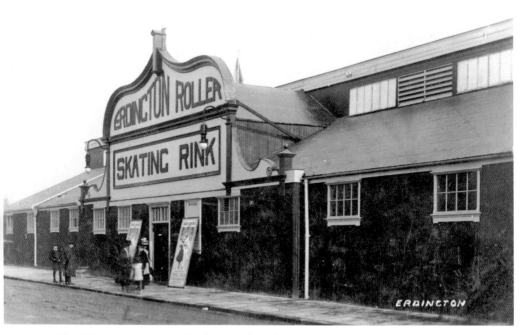

A similar rink on the northern side of the city, but a less imposing entrance. The large posters either side of the doorway seem familiar, being much larger versions of the Components Ltd advertising card.

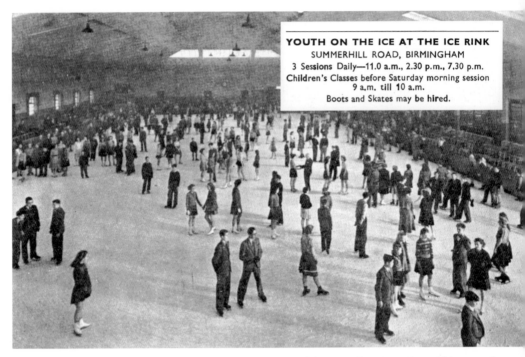

As far back as the 1870s, Birmingham possessed two or three ice rinks. More of a swishing sound came from an ice rink, along with flurries of tiny pieces of ice. This is an advertising card. The scene is thought to date from the post-Second World War period.

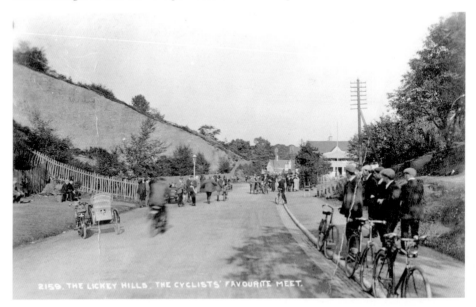

Rather like the motor car in later years, the bicycle opened up new and exciting opportunities for work and for leisure, including racing. Many people cycled to work, while others joined cycling clubs. Birchfield was a notable club. It was invigorating to explore the Warwickshire countryside. It could be exciting to take part in road races. The card above, franked 1913, illustrates what a draw the Lickey Hills had become at weekends.

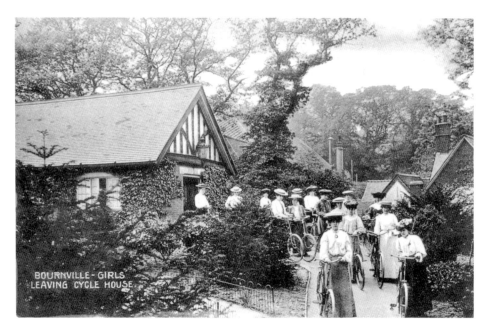

Cycling in the genteel, female manner, pre-1914. Despite the code of stifling decorum, cycling constituted a form of liberation, of increased and valued independence. These Bournville girls are probably all Cadbury employees using a Cadbury-provided cycle 'shed'.

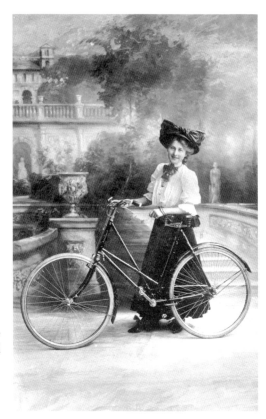

Raleigh of Nottingham were perhaps the most famous make of push bike for many years. This was a promotional card issued by 'The Raleigh Cycle Depot, Paradise Street, Birmingham'. Miss Phyllis Dare was a well-known and popular stage artiste.

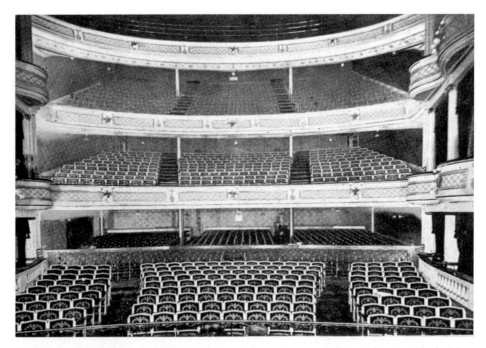

The Theatre Royal experienced a history almost as dramatic as some of its productions. The building was twice badly damaged by fire, rebuilt and refurbished. Now a blue plaque marks where the theatre once stood in New Street, 1774–1956. The postcard above was franked 12 April 1909.

Generally held to be the best theatre in the city, the Royal was able to attract the top talents of the day and to stage the classics, the controversial and the comic. The painting is of Prospero from Shakespeare's *The Tempest*, presented by Mr Tree's Company during the first week of December 1905. Sir Herbert Beerbohm Tree (1853–1917) was a great character actor, a master of stagecraft and highly successful.

'Direct from its Brilliant and Successful Season at Daly's Theatre, London', states the back of the card. This was not an exaggeration – *Charley's Aunt* (1892) had broken all records for plays of any kind, with a London run of 1466 performances. It was now booked to appear at the Prince of Wales Theatre, Birmingham. It tells the story of one young man helping another young man out of a scrape by pretending to be 'Charley's Aunt', a rich, elderly lady from Brazil, 'where the nuts come from'. A clever illustration almost gives the game away. This farce was written by a well-known actor, Brandon Thomas.

"A MIDSUMMER NIGHT'S DREAM".

Under the inspired and inspiring leadership of Sir Barry Jackson (1879 –1961) Birmingham Rep (founded in 1913) became one of the leading repertory theatres in the country.

While it could be highbrow, the Theatre Royal was not averse to staging pantomimes or light musical shows by entertainers like the group shown: 'The Co-optimists' in a Pierrotic Entertainment in Two Parts" was said to be 'The cleverest Entertainment in the British Isles' (*Sunday Express*). Pierrot shows enjoyed a vogue period of success during the earlier years of the last century, not least at the seaside. One of the men shown above is Stanley Holloway; he went on to considerable fame as an actor and comedian, and is known for playing Mr Dolittle in the film *My Fair Lady*.

A Christmas greetings card from 1904. This palace of varieties was opened in 1899 in Hurst Street. Music Halls were very popular at this time and more accessible than the theatre to the man in the street. Given the spelling of 'favourite', is there an American influence at work?

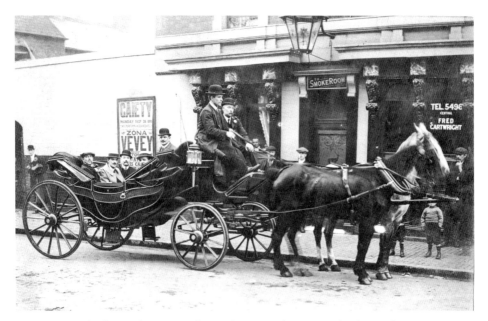

Having enjoyed a few 'snifters' (note the smoke room of a presumed pub) are these young stage-door Johnnies who are off to the Gaiety music hall? Fred Cartwright was the licensee of the White Hart at 187 Aston Road. Wheatley's Transport provided the splendid taxi. Zona Vevey, top of the bill, was a singer of sentimental songs with a fine, clear voice.

Partly due to the influence of impresario George Edwardes, a group of particularly talented, attractive and intelligent dancers and singers achieved a unique, elegant status as the Gaiety Girls. Some of the girls went on to enjoy long and successful stage careers as actresses; some married into wealthy and aristocratic families.

Entertaining as music hall artistes could be, it was the flickering images of silent films that provided entertainment for the masses. This little picture house on the Lichfield Road, Aston, opened in about 1913. After cutting his teeth in *Keystone Kops* films, Chaplin's career really got underway in 1914. *One A.M.* was made in 1917 – 'A scream from start to finish', according to the card.

Silent films were supplemented by sounds. An exciting chase could be made a thrilling one if a pianist near the screen played appropriate snatches of music. A small ensemble could be even more compelling, especially if a heartrending tune was played on a violin. The Savoy, a small cinema, opened in 1911 as the Sparkhill Picture Palace, adopting the Savoy title in 1923. Later programmes included mini concerts and Pathé Gazette news.

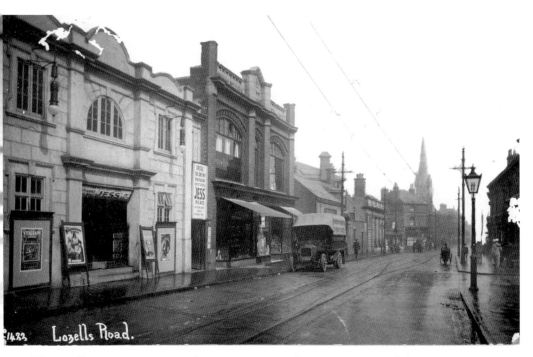

The Lozells Picture House opened in 1911. Ten years later its owner installed a cinema organ, eventually replaced by a prestigious Wurlitzer in 1927. The cinema was also the first in Birmingham to open on a Sunday, in 1933. Sadly, this cinema was destroyed in a 1942 air raid.

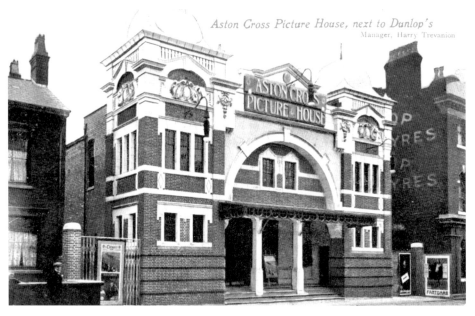

This is the picture house referred to on the previous page. The Dunlop factory building is immediately to the right where 'YRES' can be seen. Post-First World War, Dunlops had a massive, modern factory built close to the Tyburn Road, Erdington. On the back of the card is written, 'Receipts for week ending Ap 22, £103.15.9. H. J.' – presumably Trevanion, the manager mentioned on the card.

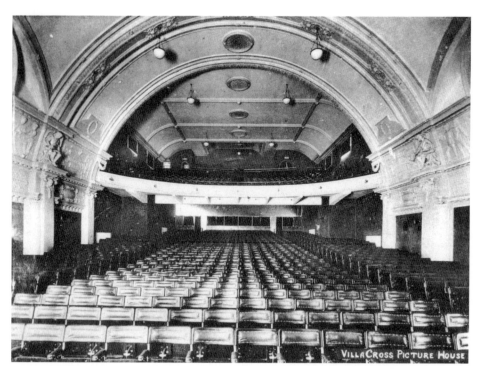

The auditorium of a cinema that issued this card in May 1916 to celebrate its first anniversary. 'This increasingly Popular Picture House' was the Villa Cross, Handsworth.

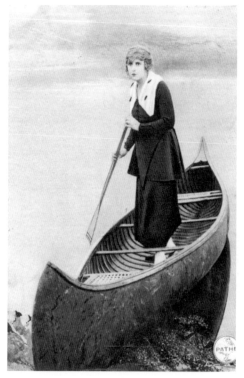

Pearl White was one of the most popular heroines of silent films, frequently cast as a fair maiden pursued by black-hearted villains. Many a time she was found in a perilous situation, tied across railway lines for instance, and rescued in the nick of time, while crashing chords thumped out from the piano. A film series *The Perils of Pauline* was very popular.

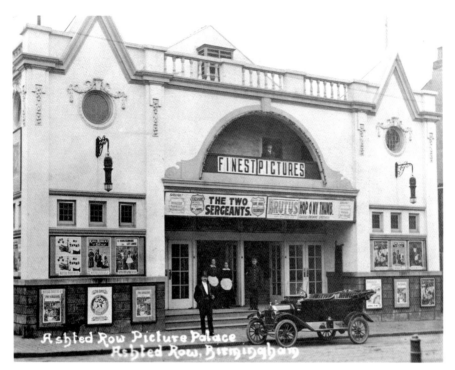

This early cinema, opened in about 1912, had an Aston Villa connection, being owned by Jack Devey. Devey played at inside-right and centre-forward during the 1890s and skippered the team that won the double, both the League and Cup competitions, in 1896/97. The cinema adapted to the talkies in 1934. In the doorway stand two people, presumed to be members of the staff because of their white collars and neat aprons.

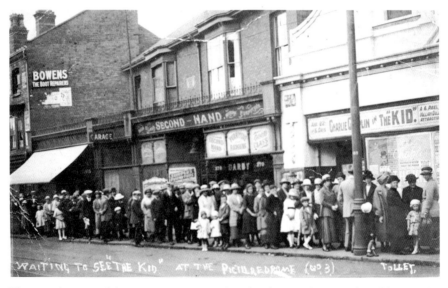

The exact location of this cinema is uncertain but the photographer gives his address on the back of the card – Ivor Road, Sparkhill. *The Kid*, Charlie Chaplin's smash hit of the early 1920s, was one of the most iconic films of the silent era and generated many cinema queues.

The Kid: This budding child star was Jackie Coogan.

1919—DECEMBER *A Day's Pleasure* (2 reels)

1921—FEBRUARY *The Kid* (6 reels)

Charlie's motherly care of his adopted baby, his instilling of standards of behaviour, their manner of living, is comedy touched with tears. His fight to save his "kid" from the hands of officialdom, austerely stretched out to take him to frigid safety, leave the tears with no comedy to dry them. The ensuing battle to rear the child himself, without the interference of cruel philanthropy, is an epic blend of comedy and tragedy, where Charlie's well-known indomitable spirit reaches new heights of endurance.

There is burlesque too; but even burlesque, in the hands of this incomparable master, undergoes a strange metamorphosis, and approaches poetry. The famous dream sequence of *The Kid* is an example of this.

Here is one review – an excerpt from *The Little Fellow* by Peter Cotes and Thelma Niklaus.

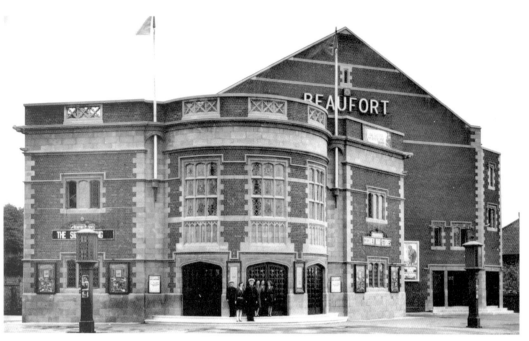

This state of the art 'palace of dreams' opened in 1929, making a bold statement of modernity even though the building included features in mock-Tudor, imitating perhaps some of the Hollywood props. This cinema became so popular that by 1937 it had been enlarged to seat over 1,500 people.

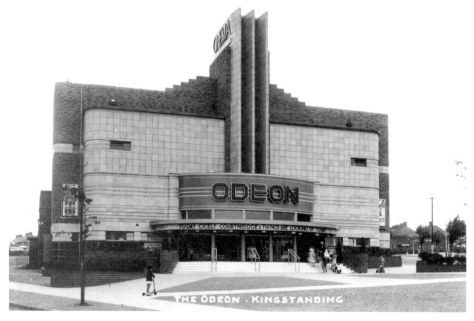

Another rightly praised example of modernity. This cinema in Kettlehouse Road was opened in 1935 by a local MP. The cinema stood facing a large roundabout encircled by shops and a pub. The three fin-like towers and the extensive use of tiles enhance the quality of design adopted.

EUGENE
THE ROYAL COMMAND VIOLINIST

The major forms of professional entertainment, the theatre and especially the cinema, were well supplemented by amateur and semi-professional or professional entertainers. Amateur dramatic societies, often associated with a church or some other institution but sometimes independent, were numerous. Individuals and groups with musical talent abounded. A few examples follow. Eugene (probably not his real name) and his Magyar Orchestra performed daily at the Princes Café in Temple Street, courtesy of Wimbush and Sons, a city-wide baker's and confectioner's. Lewis's store formed a similar arrangement with Jan Berenska.

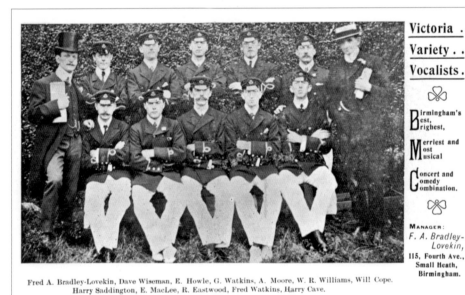

Victoria .
Variety . .
Vocalists .

Birmingham's Best, Brightest,

Merriest and Most Musical

Concert and Comedy Combination.

MANAGER:
F. A. Bradley-Lovekin,
115, Fourth Ave.,
Small Heath,
Birmingham.

Fred A. Bradley-Lovekin, Dave Wiseman, E. Howle, G. Watkins, A. Moore, W. R. Williams, Will Cope.
Harry Saddington, E. MacLee, R. Eastwood, Fred Watkins, Harry Cave.

Given their uniforms, did sea shanties feature in their repertoire?

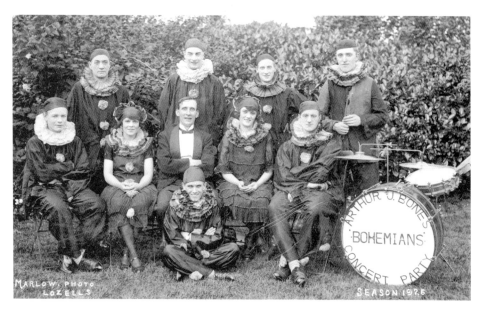

Another group of pierrots, this one in more conventional dress than the flamboyant group shown at page 66. Presumably, like the photographer, they are from the Lozells area. Season 1926.

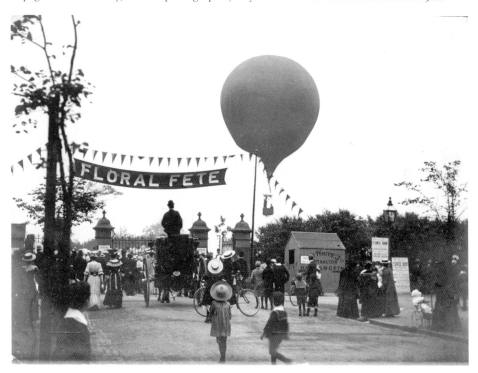

Time for fun and games in the park. Thanks to the combined efforts of public and private enterprise, Birmingham was well blessed with public parks and open spaces. Victoria Park, Handsworth, came into particular public favour when holding its annual flower show. The above 1914 photograph illustrates the point. George Lemprière (of French descent), owner and pilot of the balloon, lived in nearby Wilton Road. At fêtes like this one he welcomed paying passengers aboard.

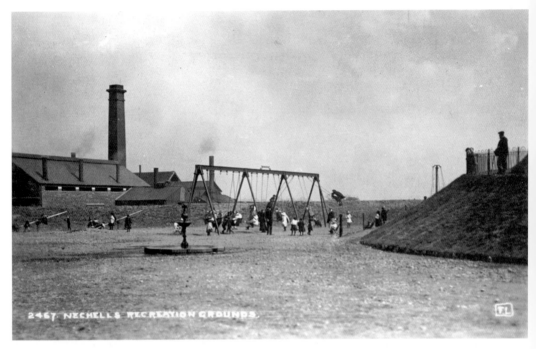

Be their sites ever so humdrum, swings hold a great exciting appeal for children. Areas in parks were often set aside for groups of swings; one allocated to boys with a separate group for girls. It was part of a park-keeper's duty to ensure that segregation was maintained. In the background of this card, two see-saws are visible. Their upper ends appear surprisingly high.

The epitome of impish young boyhood. From his general appearance, this kid may well be a member of a struggling family. Consider the well-worn shirt, ill-fitting breeches and a pair of shoes that may well be hand-me-downs from an older sister. His sockless bare legs look unduly thin. But, for the moment, he seems happy enough. He is partly concealing his treasure – what might be a broken umbrella recovered from a litter bin? Card franked 27 April 1915.

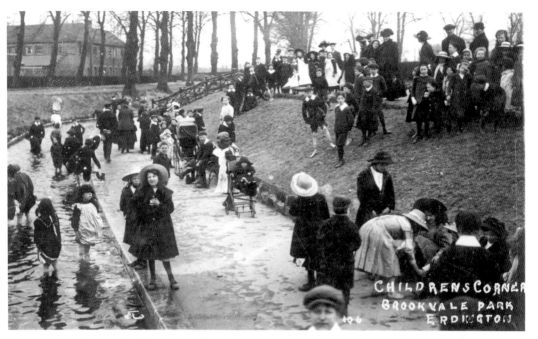

Many of the parks had pools and other water features. The card is franked 15 October 1916 but, looking at the clothing, the scene is probably one from several years earlier. The trees are bare and most of the children are warmly clad, but the hardy ones seem to be enjoying their paddle. A fine model yacht can also be seen.

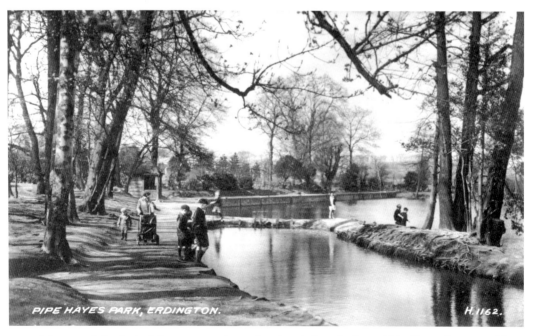

A later card, franked 28 August 1939, just a few days before the Second World War began. Buildings that had once been privately owned were bought in 1919 by the City Council. Pype Hayes Hall was retained and part of the grounds converted into an eighteen-hole golf course.

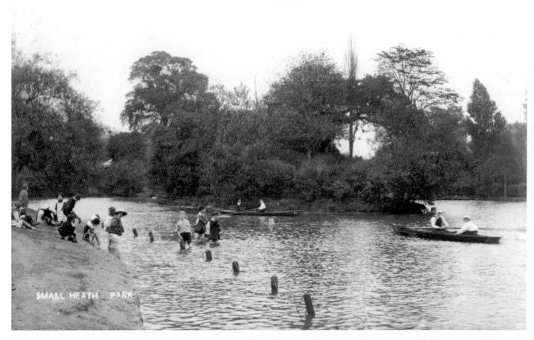

Another park and another pool, with what might have been a designated area for children to paddle in. The stumps of wood sticking out of the water presumably mark the boundary of safe from unsafe paddling, instinctively challenged by any children of spirit. (Card franked 14 October 1911)

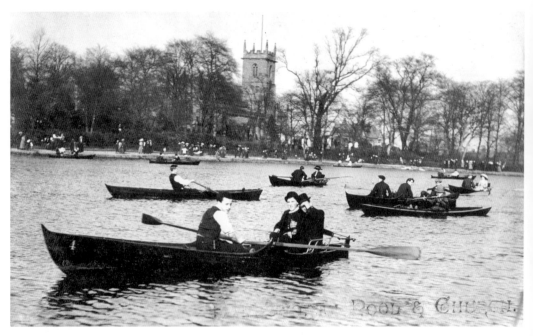

'Jolly boating weather!' As indeed it must have been given the amount of traffic – at least nine boats are visible. To the left, but not in the scene, stood the large, handsome boathouse and slipway with many well-varnished boats for hire. The tower of Handsworth Church, St Mary's, rises above the tree tops.

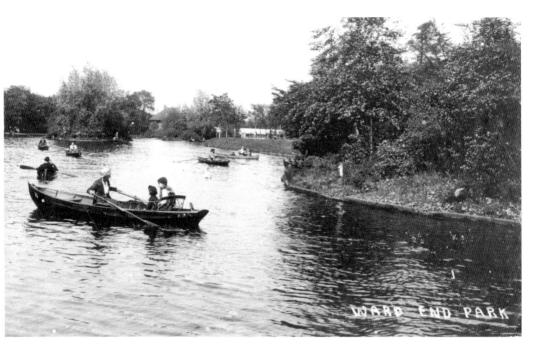

Hence the expression 'resting on one's oars'. Given the hat (it is not a knotted handkerchief), it could be mother who is chatting to the two children. The card, written in a very neat hand, on 1 September 1926, is addressed to Clamart (Seine), France. The writer, a lady, expresses concern that some people from Paris, at a conference, had never heard of 'disarmament' or 'conscientious objection'. It sounds as though the she was a member of some post-war peace movement.

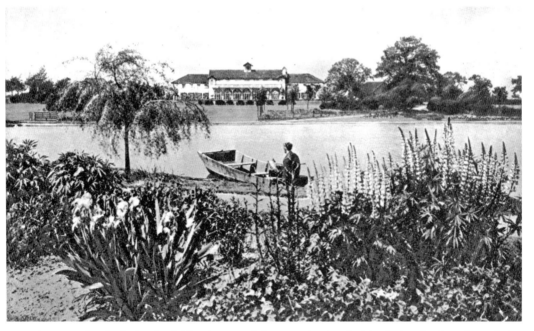

An example of relaxing by fishing in part of the extensive 'garden' in the 'garden in a factory' site. Rowheath also catered for more boisterous games, such as football and hockey.

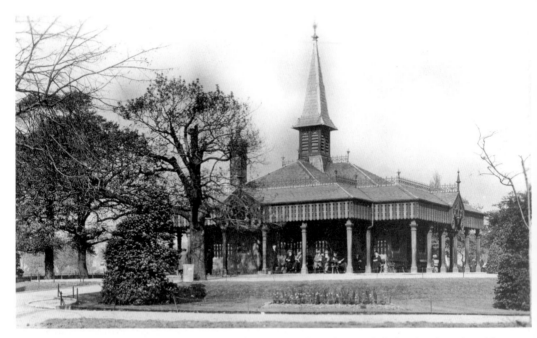

Between the wars, parks provided a range of facilities. This often included a bandstand, public conveniences (sometimes semi-concealed in a small thicket of rhododendrons), and a refreshment room. Above is one of the grander cafés, which also provided free shelter as can be seen. The design is somewhat reminiscent of a pagoda.

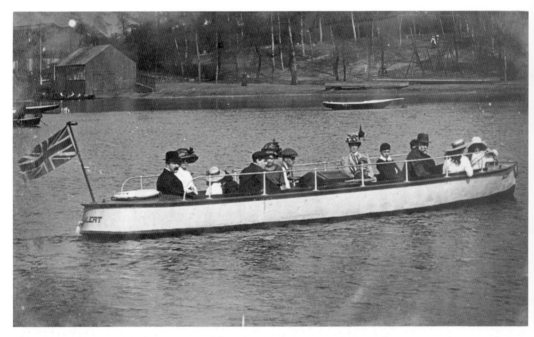

The time came, pre-1914, when a person did not have to be an oarsman or yachtsman to cruise around this large expanse of water. Some quite splendid bonnets are on display.

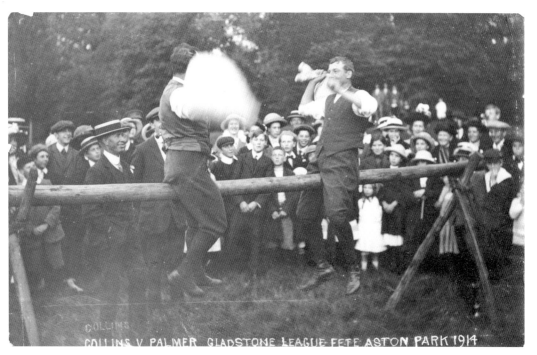

COLLINS V PALMER GLADSTONE LEAGUE FETE ASTON PARK 1914

As Gladstone, the great statesman, had died in 1898, it is difficult to be sure about the purpose of the League. It probably had something to do with missionary work or social reform. In any case, this fête was obviously well supported. It makes clear that pillow-fighting, even in this unusual form, was not the monopoly of public schoolboys in the dorm.

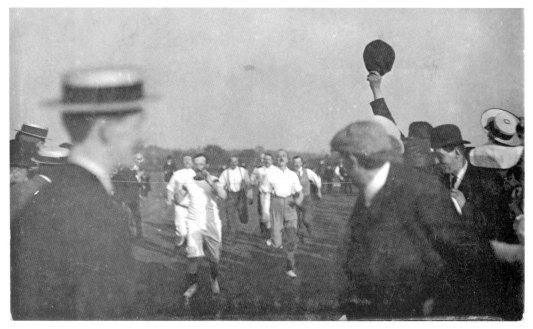

A closely contested race of the veterans, no doubt the dads. The keen runners sport running togs, others have slipped off their jackets, but one at least is still wearing his waistcoat.

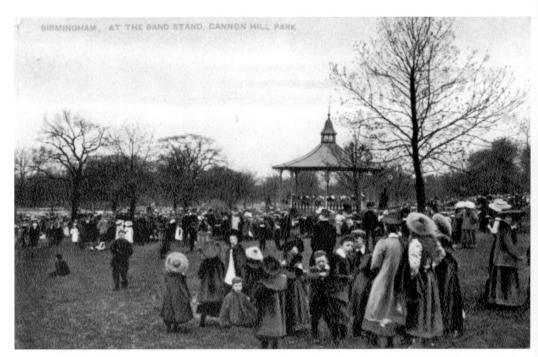

Many parks featured a focal point such as a bandstand, where crowds could assemble and in which local people usually took pride. On this Raphael Tuck card (coloured), sheet music seems to be on the stands, with the bandsmen perhaps getting ready to appear.

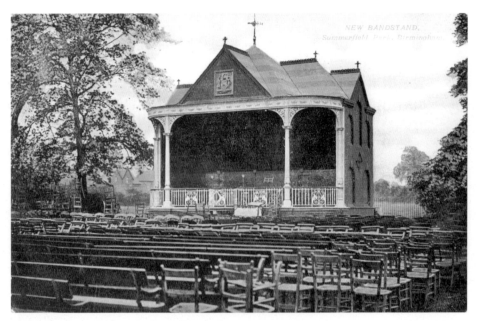

NEW BANDSTAND,
Summerfield Park, Birmingham

The card refers to this building as a bandstand – but what a whopper! Perhaps it is a conversion of an earlier building which had served some religious purpose; five crosses can be seen on the roof ridges. From the amount of seating, this is to be a concert of some significance in Summerfield Park, close to Edgbaston Reservoir. The card is franked 3 January 1908.

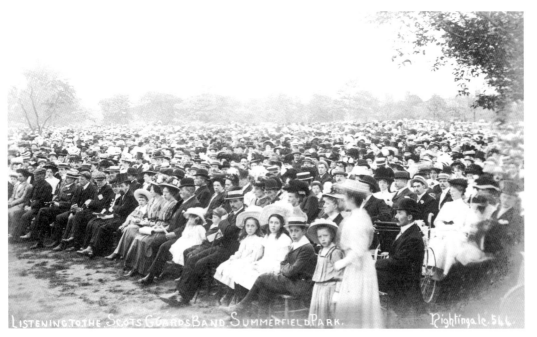

So, here we are then. The card's caption reads, 'Listening to the Scots Guards Band Summerfield Park'. This prestigious concert occupied the afternoon and evening of Sunday, 30 August 1903. 'Estimated Number of Persons Present 60,000. Total Collections £120.1s.4d.' (Summerfield Park's Musical Committee – Souvenir Programme)

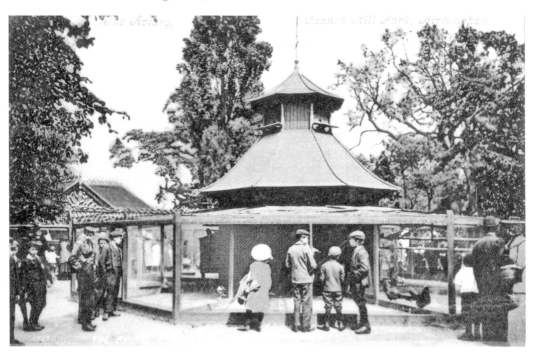

A pre-First World War coloured card, published by Valentines, a firm of good standing. This park, Cannon Hill, added to its attractions by installing an aviary, of particular appeal to youngsters.

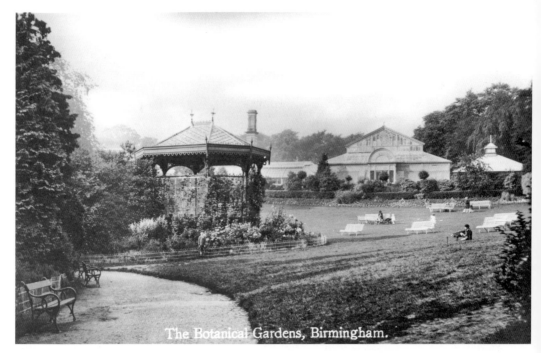

The Botanical Gardens, Birmingham.

A 'park' with a history, located in Edgbaston. The gardens were planned, laid out and stocked in 1831 by the highly regarded botanist and landscape gardener, the Scotsman John Loudon (1783–1843). His numerous publications include *The Encyclopaedia of Gardening* (1822).

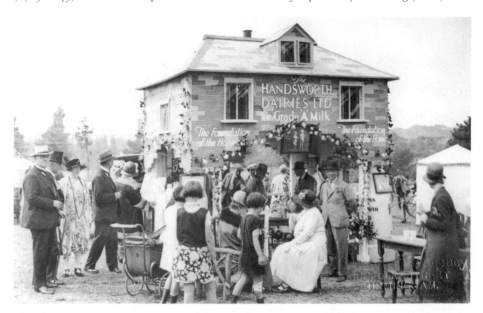

This three-dimensional advert is thought to be in Handsworth Park, a prime location for outdoor exhibitions, fêtes, and displays of all kinds. This dairy was quite a sizeable firm, located in Handsworth. The health and purity aspects of their product are being well promoted as 'The Foundation of the Home'. From the way people are dressed, the scene is probably from the late 1920s.

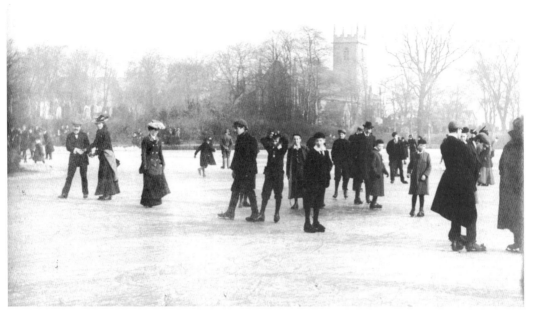

Through the mist or fog can be seen, in blurred form, what could be the tower of St Mary's Church, Handsworth, looking out across the frozen pool. At the left edge is the possible end of the pool's island. This is most probably a pre-First World War scene.

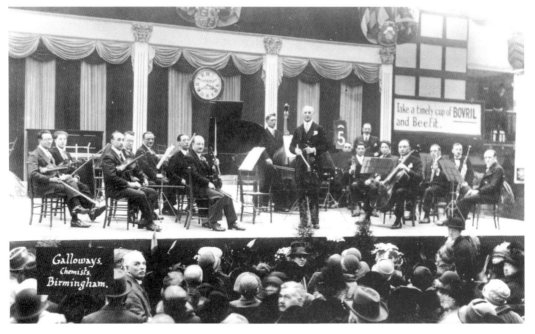

The Bovril advert, the stage setting and adjoining features, including the clock, suggest that this might well be an afternoon musical concert at a Bingley Hall Exhibition. Galloway's, between the wars, was a major chemist's and photographer's. As befits their trade, the photograph is clear and sharp, as players and audience await the 'Skater's Waltz', or excerpts from *The Merry Widow*.

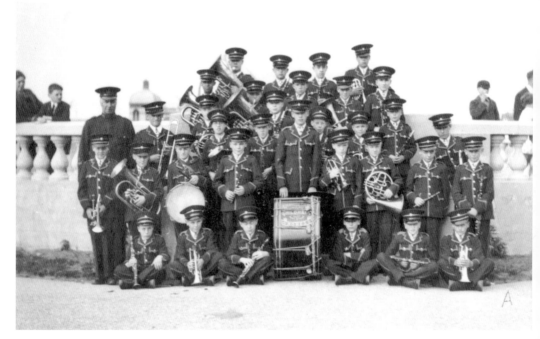

From a preponderance of strings to one of brass. A note on the back of the card reads, 'Erdington Cottage Homes'. These homes looked after children in foster care. This sizeable band seems mostly composed of youngsters and the title referred to may be on the drum.

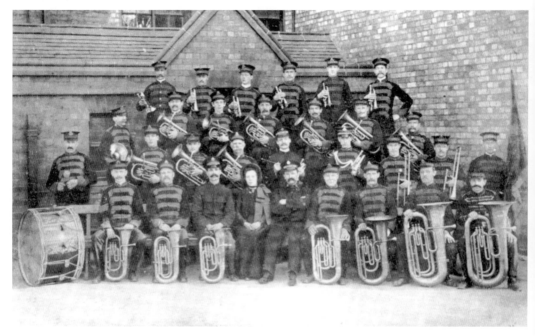

A 'Sally Army' band was usually one of the most popular brass bands, not simply because of their high quality of musicianship but for the respect and admiration in which they were held by the public for their charitable work. There is one lady present – did that mean one tambourine on strength?

This card serves as a reminder that giving away cast-offs to charities has a long history. Once the donor has given his address, the card can be posted to Loveday Street.

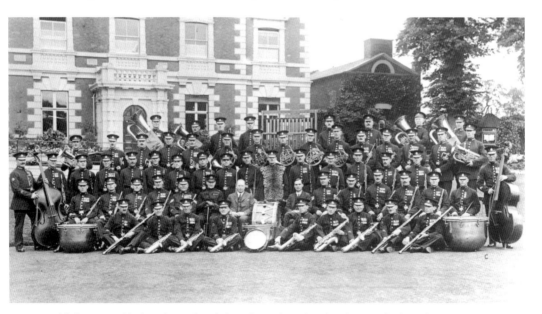

Could there possibly be a larger band than this? The police band enjoyed a long history, having been founded in 1864. Apparently, the band was always in a position to buy the best instruments, so that it formed 'the best equipped military band in the country ... The Band is a great attraction to the public, and wherever it performs, crowds of people assemble.' In fact they principally played in parks and the Town Hall.

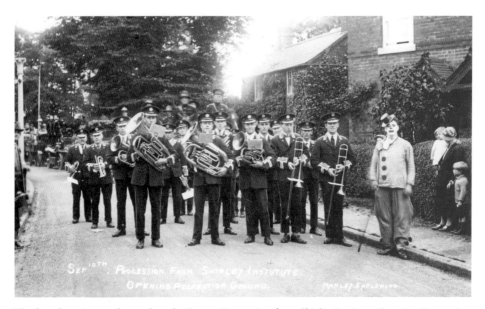

The faint lettering on the card reads, 'Sep 10 Procession from Shirley Institute Opening Recreation Ground.' Behind the band, uniformed men on horseback follow what appear to be four-wheeled carts serving as floats. Conceivably, the lone clown is itching to restart his clowning.

'If music be the food of love ...' may it soon speed up a little.

LIFE WOULD BE BLISS,
DANCED THROUGH LIKE THIS!

'Say no more, I'm your man.' Well, this was the decade of 'the roaring twenties', with flappers, spats and all that jazz.

DO YOU DANCE THE CHARLESTON?
GIVE IT UP AND PLAY FULL BACK
FOR ASTON VILLA INSTEAD!

'Well, we're not all gigolo smoothies.' Many chaps did their clumsy, diffident best in ballroom dancing in the category between the smoothie and the clodhopper. This is another card from the 1920s, when the Charleston was all the rage. Credit is due to the girl for picking the right football team!

With dance bands galore, the best of them broadcasting regularly on the radio, and an avalanche of recordings on 78 rpm records for the gramophone, the 1930s were a wonderful, exhilarating period for ballroom dancing. Would-be dancers learned their steps in a variety of ways, including at school in some girls' grammar schools, taking lessons at a dance studio like the one below or simply through dogged perseverance.

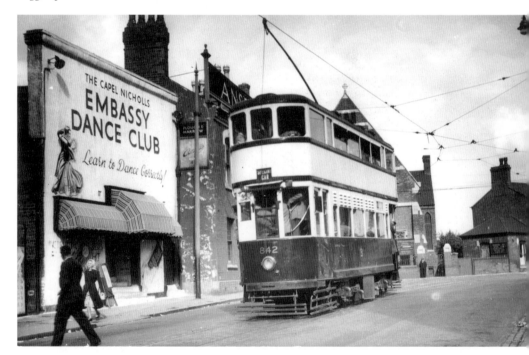

Then there were public dance halls – even in 1952. Before that Saturday night hops of private or semi-public kind were held in all manner of buildings: a church hall, a scout hut, a pub, a sports pavilion, a working men's club, a hotel, or even an aerodrome hangar.

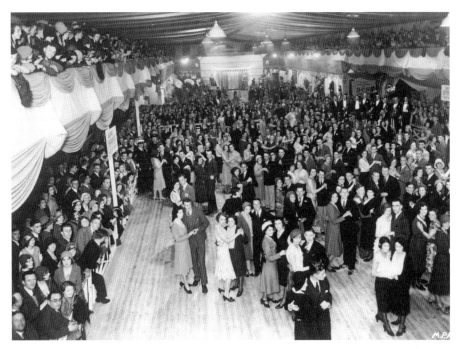

B. C. S. – Birmingham Co-operative Society. Having started life in 1881 as a small acorn, the Co-op had now become probably the largest retailer in the city. A celebratory dance brings the exhibition to a happy close. No doubt the last dance would be a slow waltz to the tune of that evergreen favourite 'Goodnight Sweetheart'.

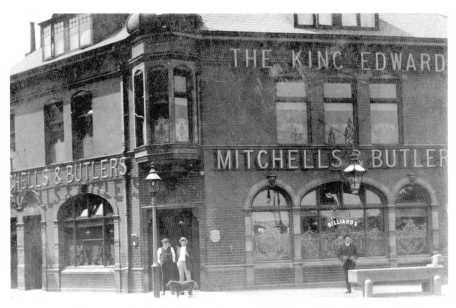

For many working men the local pub served as a social club: a drink of ale, a good chinwag, chaffing the landlord, the buxom barmaid, a game of dominoes or even billiards, as above. Note too, the horse trough for thirsty horses. This King Edward VII pub was located in Lichfield Road, Aston and opened in 1904. Card franked 29 May 1911.

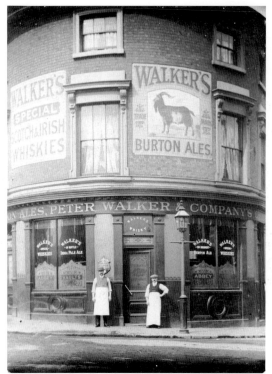

While the two largest brewers in Birmingham, Mitchell's & Butler's and Ansell's Aston Ales, ran the lion's share of pubs in the city, other brewers included Davenport's and Walker's, the latter having started business in Scotland. This pub was located in Hockley. The card refers to the Coronation of George V and is franked 27 June 1911.

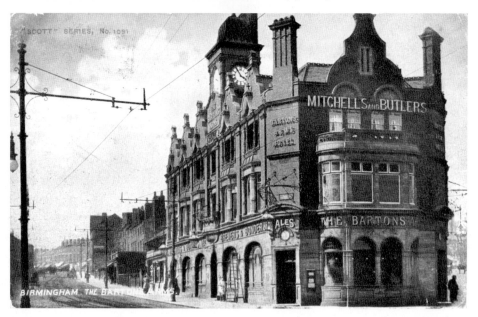

The Bartons Arms in High Street, Aston, a pub with an impressive pedigree. This building dates from 1901. The pub enjoyed close and helpful neighbours for many years, namely a small cinema left (not visible) and Aston Hippodrome (Music Hall) opposite the corner frontage. The pub's interior earned fame and reputation for its stained glass and superb tiling. Public support for these features helped bring about the pub's restoration in 1980. Postcard franked 7 Feb 1907.

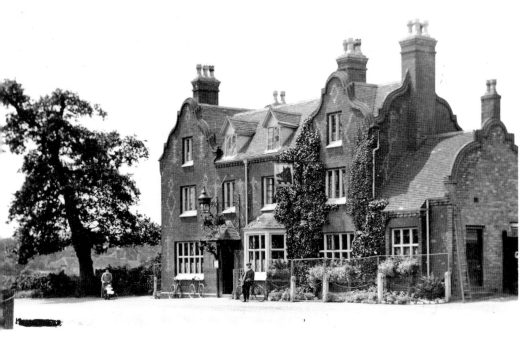

When this postcard was franked in 1912, the Boar's Head pub, or rather, hotel, stood in Perry village, on the outskirts of the city. Just behind the large tree spreads Perry Park. The style of the building and its general appearance create the impression of an attractive country house. The inn sign appears at first floor level, surrounded on three sides by foliage.

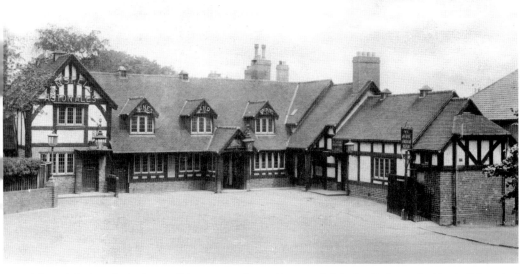

This pub looks to be in fine condition on a card posted in 1934. It is in fact Erdington's oldest building, sited in Bromford Lane and dating from around 1400. (The date of 1306 given on the postcard is not strictly accurate.) Its fine condition is due to restoration work to retain its timber framing, carried out four years earlier. Further repair work was carried out in 1971. For a time the pub had been called the Green Man.

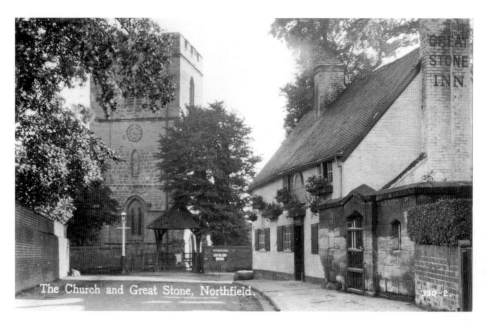

The Church and Great Stone, Northfield.

Before Northfield became home to workers from Cadbury's and the Austin Motor Co. among others, it had been a country village, with church and inn near neighbours. Close by the inn there had once been a pound where stray animals were corralled until reclaimed, for a fee, by their owners. The church and pub share long histories.

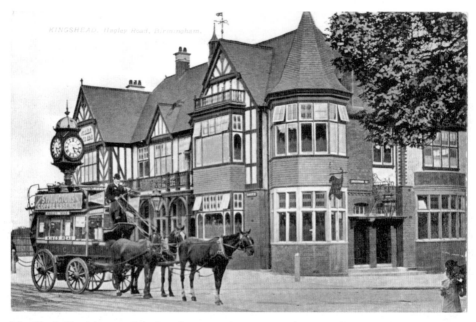

KINGSHEAD, Hagley Road, Birmingham.

The King's Head is one of the best-known pubs in Birmingham, not because of its patrons, but its age, appearance and location. It dates back at least to the days of the horse bus, serving as the terminus of the service from New Street. Positioned on a very busy crossroads on Hagley Road, this pub has also served as a landmark, not least for myriads of passengers on the Outer Circle no. 11 bus route.

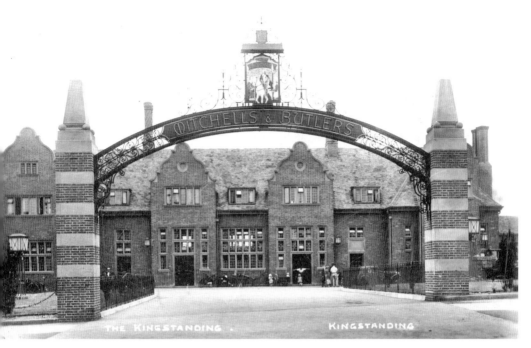

As part of the circle of commerce around the roundabout mentioned at page 73 was this large pub. The Kingstanding was established to quench the thirsts of tenants of the new council house estate of the mid-1930s. This card is franked 1936. The style of building might well be dubbed '1930s mock-baronial'.

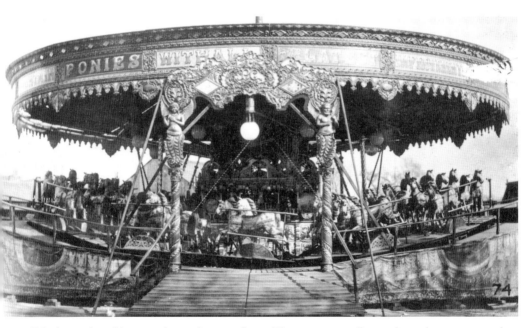

Fairs have a long history and can take many forms. They were generally popular and none more so than Birmingham's annual Onion Fair, held at the Serpentine Ground in Aston. A major Midlands' stager of fairs was Pat Collins, a household name. It was good to have the dirty, ashy surface of the ground covered by exciting machines, mechanical powerhouses in the form of road steam engines.

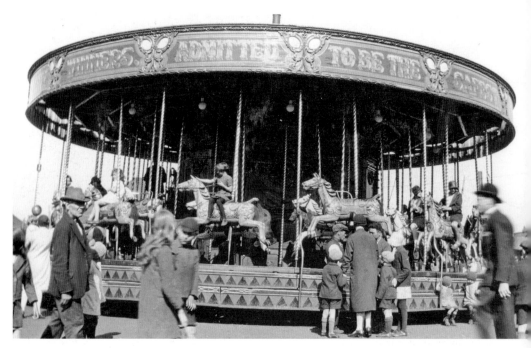

This card's back reads, 'Frank Wilson's Gallopers at Birmingham Whit Fair, 1929'. Some forty years on from the 1889 roundabout, no major change is apparent. The dappled grey beauties, as they gently rose and fell, were popular with all age groups.

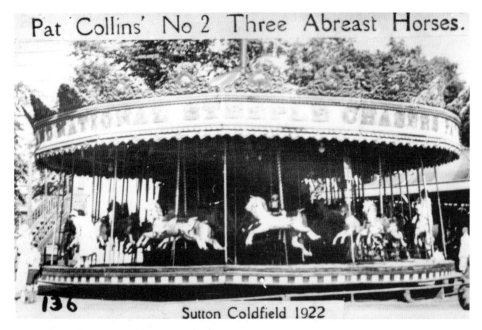

Pat Collins always seemed to be on the lookout for new ideas and amusements, hence the additional horses. Sutton Coldfield was the affluent neighbour of Birmingham but that hardly mattered; the joy of rowdy, noisy fairs was classless.

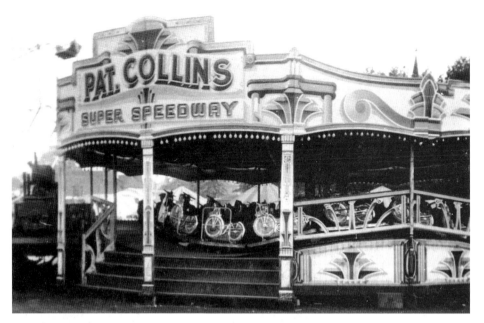

Back to the Serpentine Ground some years later and Collins has turned to account the popularity of speedway, or dirt track, racing. This did not mean that horses had been supplanted; it was simply the arrival of an added attraction to join the helter-skelter, dodgems, big wheel, wall of death, cake-walk and swing boats.

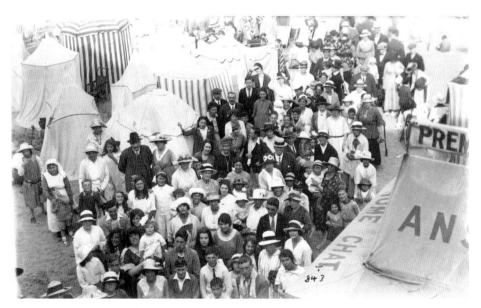

At fairgrounds generally, there was much that supplemented the mechanical marvels. Sideshows, stalls and booths enticed the public, offering the bizarre and grotesque, the challenging and appealing. Such attractions might include rifle stands, boxing booths, coconut shies, fortune-telling, gingerbread stalls and refreshment tents. The 'ANS' that can be seen here is almost certainly Ansell's and their best ales.

Back to the tranquillity and slower pace of the allotment holder. 'A man is never alone with a marrow!' Could that be the thought of this gardener? Birmingham was well-blessed with allotments and these proved to be very valuable during the years of high unemployment and, of course, even more so during wartime. Squashed into the bottom left-hand corner of the card is 'Alum Rock'.

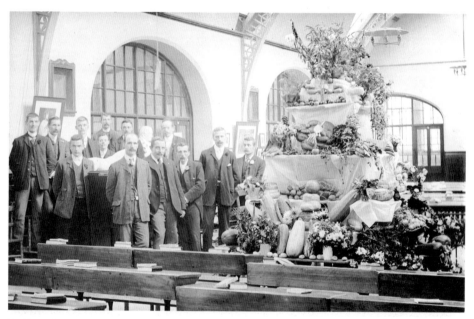

Dedicated amateur gardeners, like professionals, could be competitive. Contests ranged from small and local to city-wide. The card shown is one of several taken by a Hay Mills photographer around 1906. Shown may be a central display in a school classroom, the result of a combined effort.

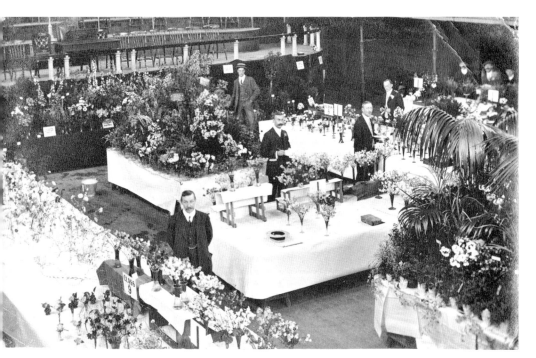

This is a typical flower and vegetable competitive show. On the back of the card is written, 'B'ham 6th Annual Show Town Hall 1912'. The signature is illegible. Tension appears to be present. Are the judges about to make their rounds or announce their decisions?

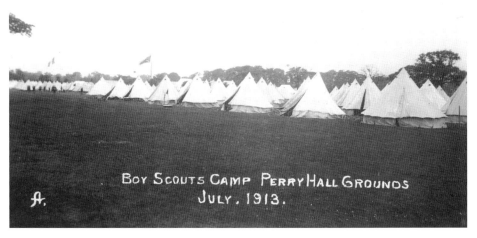

Baden-Powell (1857–1941) was a remarkable man. A soldier by profession and a General by rank, he is best known as the founder of the Boy Scout movement in 1908 and with his sister, of the Girl Guides in 1910. These became international youth movements, still widely active today and uncontaminated by any political ideology. Perry Hall grounds were privately owned at this time but in the 1930s they were bought by the Council, becoming Perry Hall Playing Fields.

At the base of this card is written, 'Our arrival – the advance party'. At the top appears 'St Michael's, Handsworth'. There's clearly plenty to sort out in this beauty spot area, close to Hagley. In terse terms, the job of the advance party is to 'get things ready for the mob'.

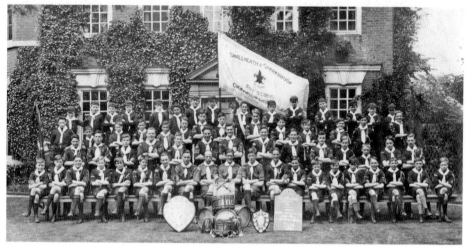

'The Midlands Scout and Cub Jamboree 1924' is written on the reverse of the card. On the banner can be read, 'Small Heath & Sparkbrook – Boy Scouts Championship'. Some fine trophies are on display. 'Jamboree' can be taken to be a large celebration and somehow has become attached to certain Scout gatherings. In 1957 the ninth World Jamboree was held in Sutton Park.

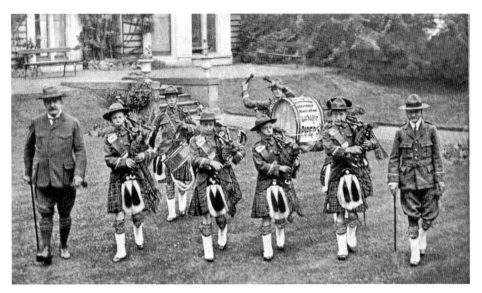

Little can be added to the card's own caption. Even so, given that the well-known photographer is from Handsworth, it is just possible that the lads are piping away in Handsworth Park, just behind the White House (see page 30). On the big drums can be read, 'The Birmingham Association of Boy Scout Pipers'.

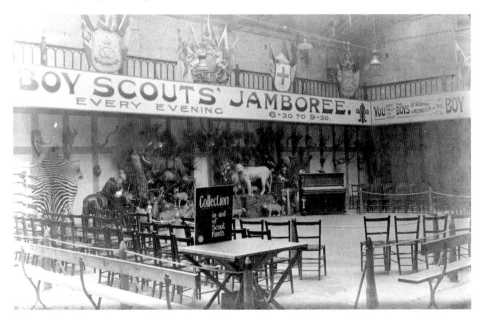

The card has been photographed by the well-known firm of Hudson, which had several addresses in the city centre. This indoor location is not known but some event takes place between 6.30 and 9.30 in the evening. The board announces 'Collection in aid of Scout Funds'. A curious feature of the room is the background of what appear to be stuffed animals, including dogs, and on the wall hangs a zebra hide.

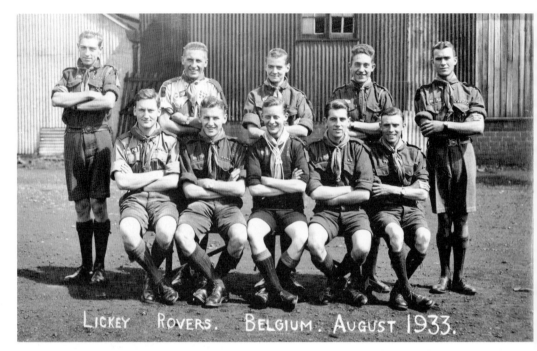

Returning to the good fresh air, bright and breezy young British 'ambassadors' are paying a visit to Belgium.

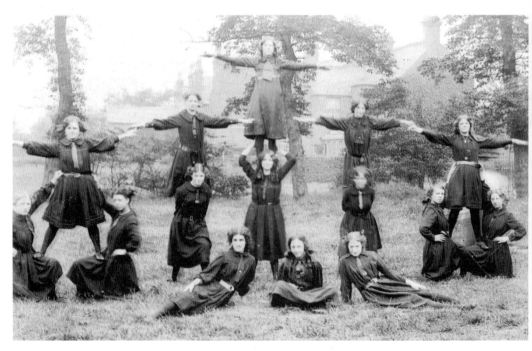

While it is unlikely that any of these young guides ran away to a circus, they made an impressive attempt to get their act together. Only one girl of the fifteen looks as though she is struggling. Card franked 25 July 1913.

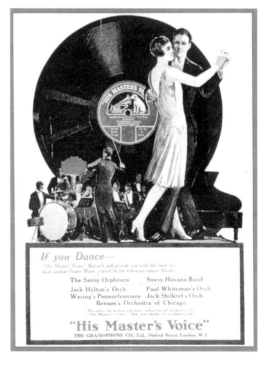

Moving from outdoor to indoor recreation, many Birmingham homes between 1900 and 1939 would have held a pack of playing cards, a board game like Ludo and a jigsaw or two. And then, by what seemed like virtual magic, not one but two forms of entertainment by sound, words and music entered the living rooms of the nation, in the forms of the gramophone and the wireless, or radio, as it later became known. While there is nothing specifically Brummagem about the photography on this page, the city would have had its fair share of phonographs and records to match, and later, records for the spring-wound gramophone followed by those powered by electricity. Clearly, the couple above are anxious to keep ahead of the Joneses!

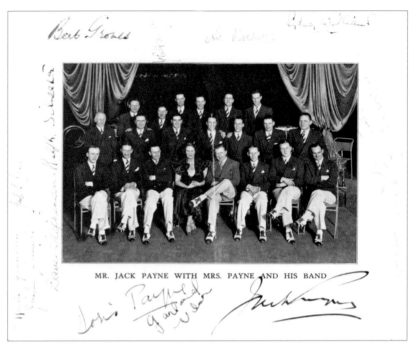

MR. JACK PAYNE WITH MRS. PAYNE AND HIS BAND

The above photograph does have a Birmingham connection. Jack Payne himself (seated centre) had attended the Rookery Road School and then the Handsworth Grammar School for Boys. After service in the Royal Flying Corps as a pilot, he formed a highly successful dance band, becoming leader of the BBC's first official dance band in 1928.

THE period of a year covered by this issue of the Handbook—August 1st, 1927, to July 31st, 1928—has seen the transference of the allegiance of listeners in the Midlands from the old Birmingham Station (5IT) to the new Experimental Station at Daventry (5GB).

The change was necessary owing to the limited number of wave-lengths allotted to Great Britain by international agreement, and the desirability of providing an alternative programme service covering the greater part of the country. In other words, a second high-power station was required, and it could not be introduced except as a substitute for one of the existing stations.

In the early days there were frequent complaints that the new station could not be received on sets which had given so much satisfaction under the old conditions; but it is interesting to note that the number of *new* licences taken out in the Birmingham area alone since 5GB began to function reaches 15,811, whilst the renewals for the same period show an increase over the corresponding period in 1926–1927. The effect, therefore, of the change of stations cannot, on the whole, have been unfavourable. A further indication of this is the increased popularity of the Birmingham Children's Hour. The Radio Circle membership shows an increase of 6,501 since 5IT became 5GB, and during that time approximately £400 has been raised by the children towards the fund for endowing a cot in the local Children's Hospital—a fund which is now happily almost complete.

Throughout the period the B.B.C. has once more had the valuable support of the Birmingham Civic Authorities, with a very sympathetic Lord Mayor—in the person of Alderman A. H. James—at their head. Through their kindness many important outside broadcasts have been made possible, including the Symphony Concerts given by the City of Birmingham Orchestra, and regular broadcasts of the ever-popular local Police Band.

In programmes it is unlikely that many listeners will consider that they have been the losers by the change of stations. The new programme broadcast by 5GB has been enriched by contributions of considerable importance from the artistic resources of London without suffering any loss of local talent and personality. It is true that, being an alternative to 5XX, the 5GB programme has not been a comprehensive balanced programme of the normal kind, but listeners who have missed any of their old favourite programme features in the new service have always had the opportunity of hearing similar programmes through 5XX. To put it in another way, Midland listeners now have, in 5GB, a programme of wider range, experimental, free, and stimulating, while they retain the opportunity of hearing a balanced programme of the old type through 5XX.

The new responsibilities with which the Birmingham staff has been saddled have resulted in a greatly increased output of serious music. Important symphony concerts have been performed in the Birmingham studios as well as many complete operas and oratorios.

In educational matters it is gratifying to be able to record an enormous advance in what is almost a new field of exploration—that of Adult Education. Rapid strides have already been made in this branch of the work, and here again the B.B.C. is indebted to the University and local educational bodies for invaluable help. Already a considerable number of "Listening Classes" have been formed under the auspices of the various organisations interested in Adult Education; and a strong local Committee—with Sir Charles Grant Robertson, Vice-Chancellor and Principal of the Birmingham University, as President, and Professor J. F. Rees as Chairman—is doing very valuable work.

In summing up it may be safely said, after a year's working of the new station, that the change has not only been to the advantage of listeners all over England in providing an alternative programme receivable in most parts of the country, but it has also proved a benefit to Midland listeners generally, by giving substantially more than it originally took away. The temporary inconvenience of some Birmingham listeners has secured a general advantage in which most of them have, after a period of adjustment, succeeded in sharing.

The BBC received its Royal Charter in 1927 and, as the above excerpt (from the BBC Handbook, 1929) states, Birmingham was soon into the broadcasting business of 'being on the air'.

THE BIRMINGHAM
HALF-HOLIDAY GUIDE.

WITH TWO MAPS.

TENTH EDITION.
MAY, 1907.

ENTERED AT STATIONERS' HALL.

ADVICE FROM THE BIRMINGHAM SELBORNE SOCIETY.

DON'T waste wild flowers and ferns. Wild flowers perish quickly, and are, therefore, not so suitable for sending to flower services and hospitals as those grown in gardens. Don't, when on excursions, gather such quantities of wild flowers and ferns that before the day is over you throw them away by the roadside. If you do so, you take pleasure from those who love to see flowers and ferns growing ; and, if many people follow your example, rare and graceful plants are soon exterminated.

BIRMINGHAM :
THE MIDLAND EDUCATIONAL COMPANY, LIMITED.

A hundred pages are devoted to giving sound information to those of a scholarly, self-improvement disposition, especially naturalists. Note the Selborne Society advice. A half-holiday is defined as 'after midday'. With a five-and-a-half day working week, only Saturday afternoon was really available, as much of Sunday's time was commonly given to the church. Bank Holidays had not yet arrived. The remainder of the book is partly devoted to interesting locations in the Midlands and partly to Natural History. Its pages feature, for example, beetles, spiders, rare plants and ferns and fossil hunting. Just a few pages are devoted to sports, boating, bathing, fishing, cricket, Birmingham Athletic Institute, cycling, golf (three lines) and allotments.

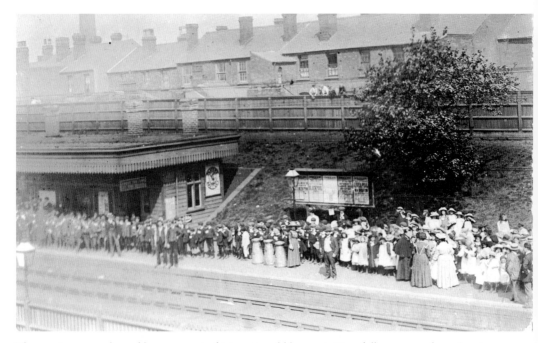

The previous page showed how one sort of trip out could be spent. Now follow some others. A note on the back of this card reads, 'Poor Children from Smethwick going to Sutton Park.' Self-evidently there are a substantial number of poor children excitedly waiting for the train.

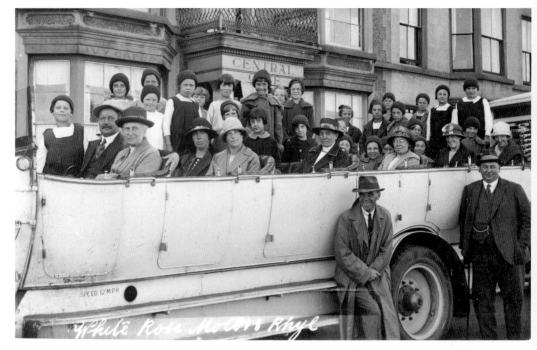

This charabanc belongs to White Rose Motors of Rhyl. It is about to set off for a trip, probably along the North Wales coast. The girls, accompanied by adults, came from the Erdington Cottage Homes in Birmingham. Note the speed of 12 mph shown by the charabanc's door.

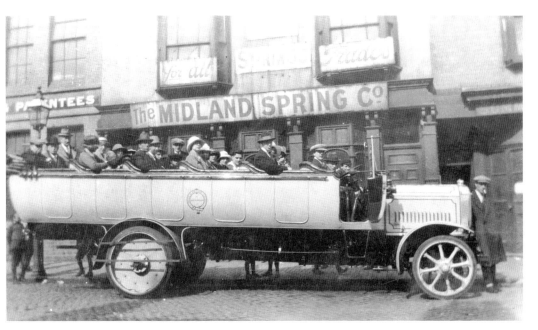

On the back of this photograph is written, 'Wells & Maynard Birmingham Charabanc.' It probably shows a work's outing, but on solid tyres! No doubt these trippers reflected ruefully that the springs they manufactured could not be fitted to the charabanc.

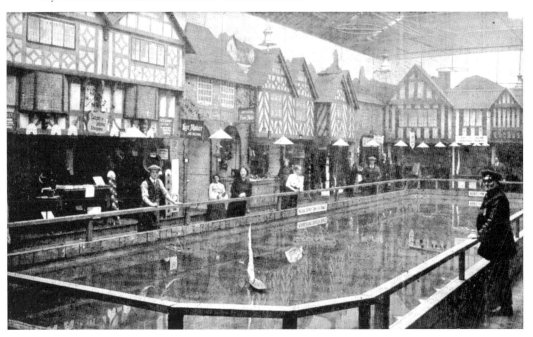

Only a trip into town for this sailing event. Unfortunately, the lettering on the various signs is too faint to be deciphered with any accuracy. Would that the parts of old Birmingham on display were so spick and span in reality.

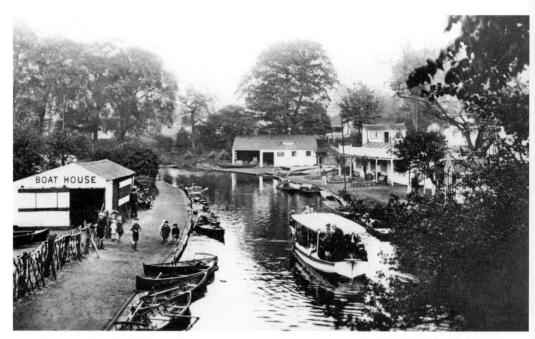

The *Valley Lass*, the motorboat shown above, seems to have been checked in its progress by boys inattentive to boating but very keen on fishing. More young anglers can be seen by the boathouse. Below, on the rooftop stands the welcome sign 'Refreshment and Tea Room'. This fine location for a picnic was situated on the Stratford Canal where coal wharves had once been.

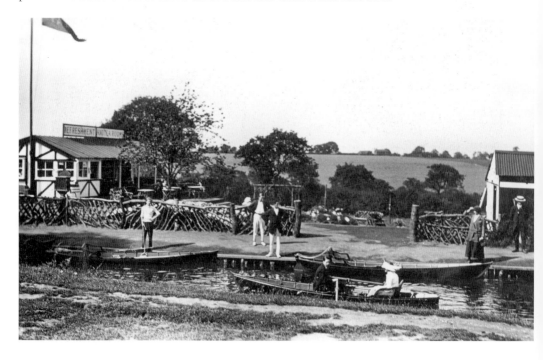

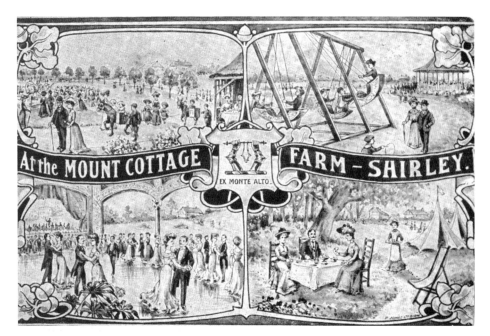

This is not a postcard for the post, as the illustrations show. Entrepreneurship is certainly at work here. Is the creator of these pleasure gardens of 1906 a trailblazer for Billy Butlin of 1930s holiday camp fame? Much is made of the acorn motif, not least with the coat of arms!

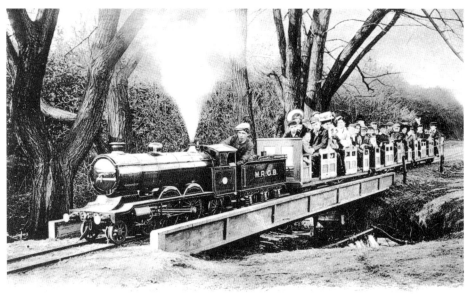

The Miniature Railway Sutton Coldfield Park (Near Birmingham).

This kind of train has long been popular and still is today, not least in garden centres. Again, the ladies' hats suggest a pre-First World War photograph. For many years Sutton Park to the north and the Lickey Hills to the south were greatly popular with Birmingham daytrippers, especially on bank holidays.

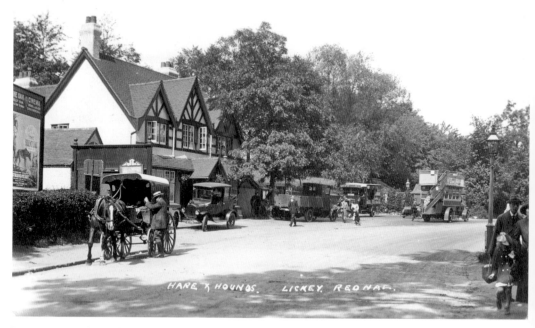

In some ways, the Lickey Hills were more accessible to many travellers than was Sutton Park. From Navigation Street in the city centre a tram service ran to Rednal. From left to right can be seen what could be a bread van, a Ford T—?, two motor lorries and an open-top motor bus, all, no doubt, having some business with the pleasant-looking pub.

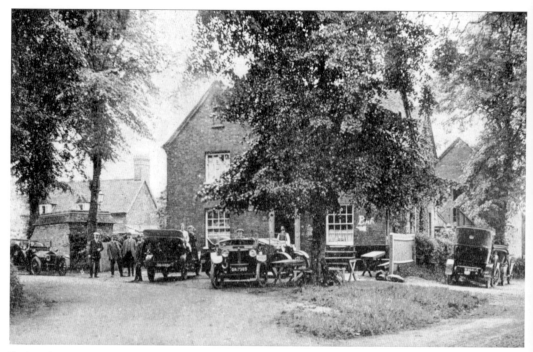

Early private car owners were well placed to travel in some style to the country village-like outskirts of Birmingham.

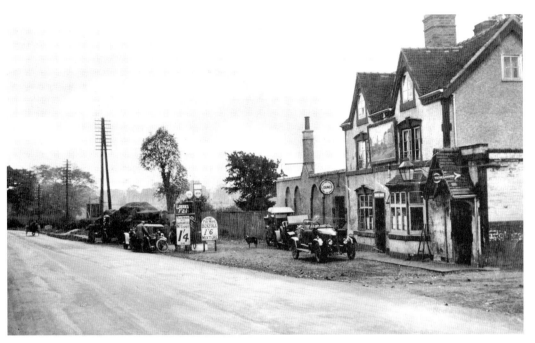

The Waggon and Horses looks as though it could do with more than one lick of paint to fit appropriately into its semi-rural surroundings. From the signs, with prices, the pub is obviously keen to attract motorists. The arrow above the door declares, 'To the Gardens'. The extension to the inn, left, is signed 'Lounge'. Above 'Benzole Mixture' the sign reads 'Don't Pay More'.

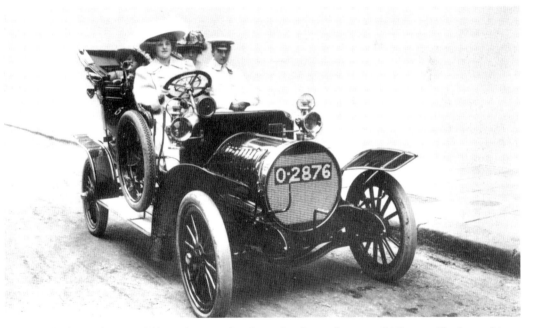

'Well, this is the car I'd like to keep my hands on. It suits my hat as well.' Presumably the card is an advertisement for 'Lowe & Wood' makers of a car with a folding hood very suitable for a lady. Was this photograph taken in a garage or car showroom?

'Mind you, even the best of cars can break down and because of their wretched hobby, perishin' kids can be a pest.'

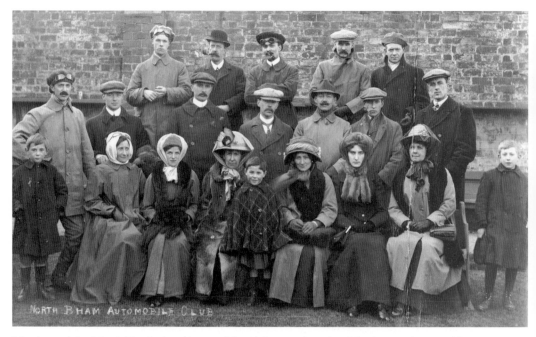

Members of the 'North Birmingham Automobile Club' – ready to head further north it would appear. The ladies are obviously adept at keeping their hats on. These early motorists look to be a hardy bunch. In effect, they were pioneers in open cars. The photograph was taken by an Erdington studio.

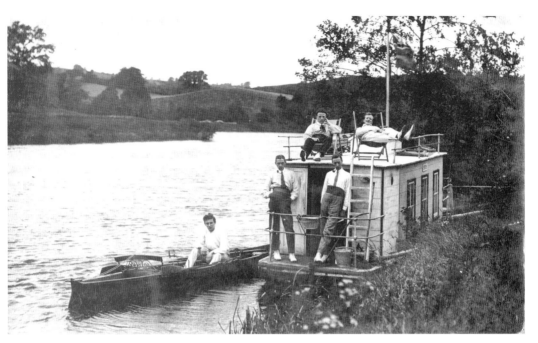

A party of smartly dressed young Brummagem bucks who travelled to the River Severn or the Avon to enjoy a lark of part of a weekend on a houseboat. The two men standing appear to have hitched their trousers too high but a closer look shows that they are wearing cummerbunds – sashes around the waist; very dashing!

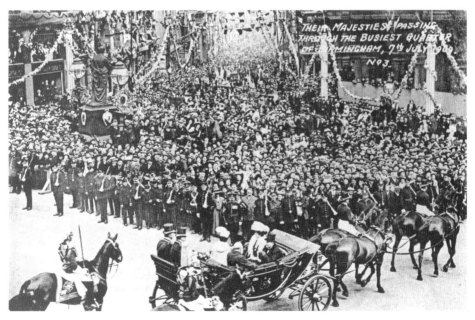

Processions, parades and pageants brought Brummies onto the streets and into the parks in large numbers. In 1907, King Edward VII and Queen Alexandra visited the city in order to open Birmingham's superb new red-brick university. The public flocked in droves into the city centre and along the royal route to Edgbaston.

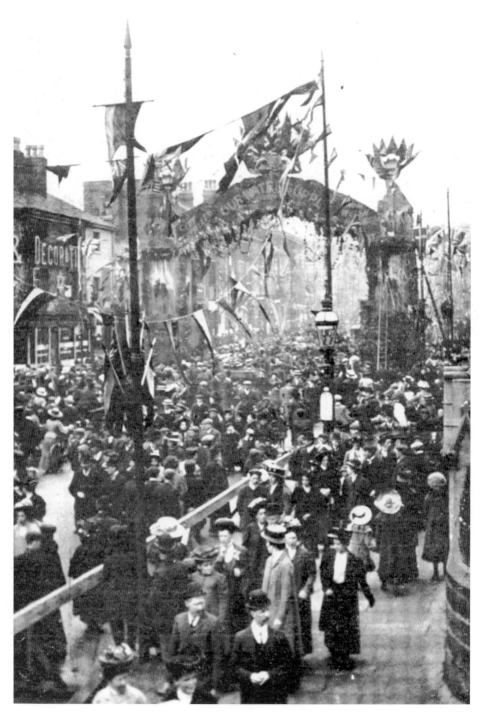

Celebratory arches had been built at intervals along the city centre part of the route, in honour of the royal visit. These arches were contributed by different groups of people, whose work was vital to the city's life, including firemen, brass bedstead manufacturers and water workers, as shown here. A few years earlier, Birmingham had been plumbed into fine Welsh water in the Elan Valley with another opening ceremony attended by the king.

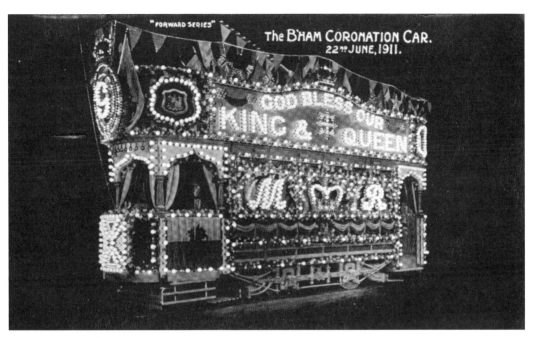

In 1911 the Coronation of King George V and Queen Mary was joyfully celebrated. Amongst other forms of celebration, Birmingham Corporation rigged up this tram to travel on a variety of routes.

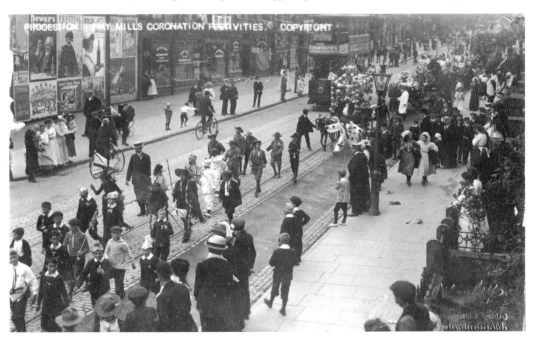

At suburban level, as here in Hay Mills, people put on their own shows. Quite a modest-sized horse appears to be pulling the 'royal' coach. The pierrot with conical hat seems to be holding one side of the horse's head. Some residents have come to the front of their garden gates. Groups of people and what appear to be floats are following after the coach. No doubt there is a band or two among them. There is no spit and polish about this procession, but it may be all the more fun for that.

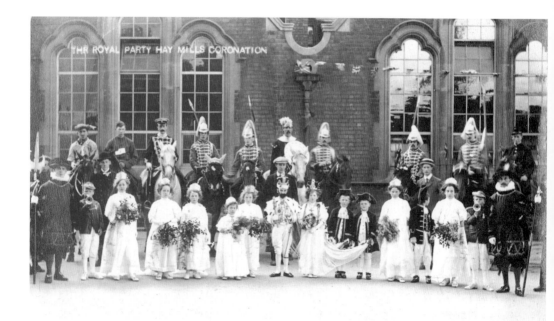

At this particular school, again in Hay Mills, a more formal and conventional approach has been taken. The royal couple are present, with page boys, ladies of the court and a watchful beefeater at each end of the line. In the background, mounted Hussars stand watch and ward.

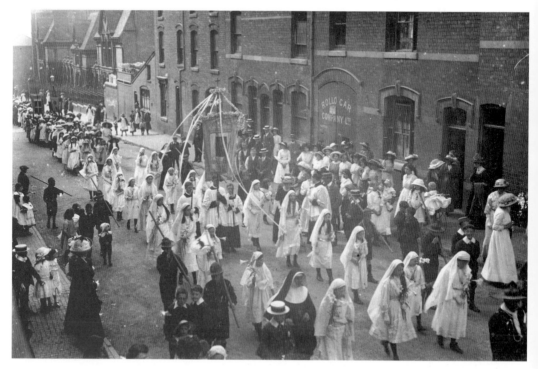

Many processions had their origins in some aspect of a religious celebration. On the back of this card is written, 'Conybere Street, Birmingham, St Alban's Procession June 1913 Lily girls – girls who had been confirmed that year'.

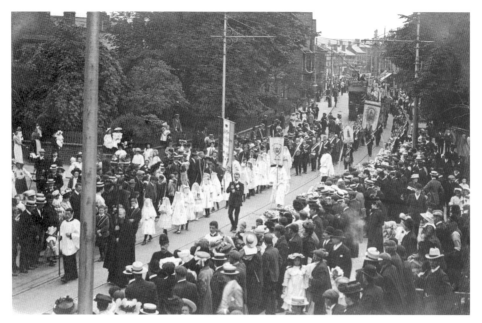

The card's sender writes, '5.8.1906. This is the head of the procession of the Pilgrimage at Erdington Abbey here a few weeks ago, about which I have told you so many times. If you could only hear them singing 'Faith of our father' – it would do you good.' It was sent to Mrs Jones in Shrewsbury.

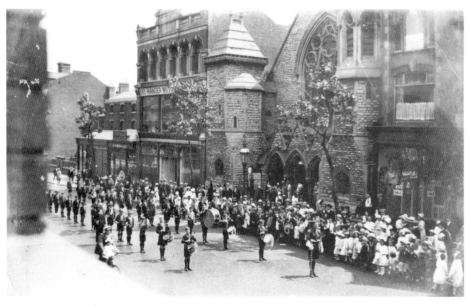

A good turn-out for the anniversary of a Sunday School: that of Immanuel Church in Broad Street. At no. 187, next door, Hanger Motors ran their business. No date is given but it is worth pointing out that the two lines of boys in the foreground may be Boy Scouts. Clues to identity include their neckerchiefs and shape of hats. Additionally, the first two in the left line are wearing kilts – are they the lads from page 101?

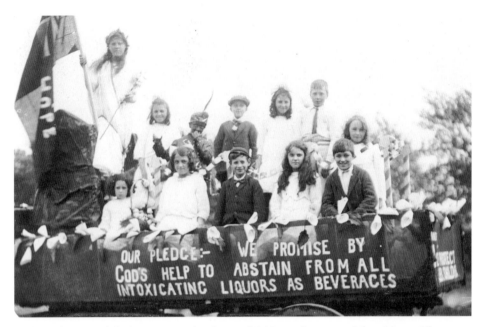

In the early years of the last century, the 'demon drink' posed many social problems. All manner of organisations were formed, many church-related, to encourage abstinence. The Band of Hope was influential among these abstinence organisations. 'Hope' can be seen written on this partly-furled flag in Lozells Street.

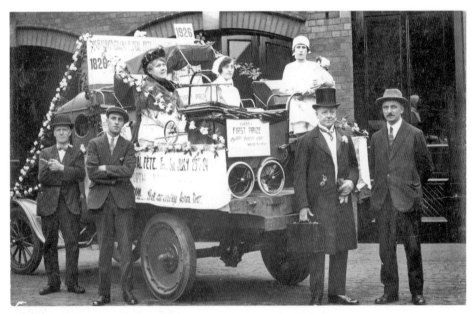

Perhaps a modest glass of ginger beer could be raised to salute this float. Part of the notice at waist high level can be made out to be 'Floral Fete Fri Sat July 23 & 24', and perhaps, 'Get an entry form here.' Civic dignitaries are involved and the first prize for this centenary celebration of the fête is a pram. The banner on the lorry's cab seems to begin 'Birmingham and District ...'

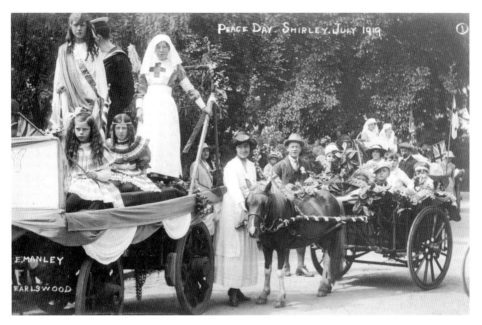

No-one questions that the guns fell silent on the 11 November 1918 when the Armistice was declared, but peace after the First World War was not formally established until the Treaty of Versailles had been agreed. On July 19, Peace Day was celebrated with parades and street parties; it represented mixed joy and sorrow for so many people.

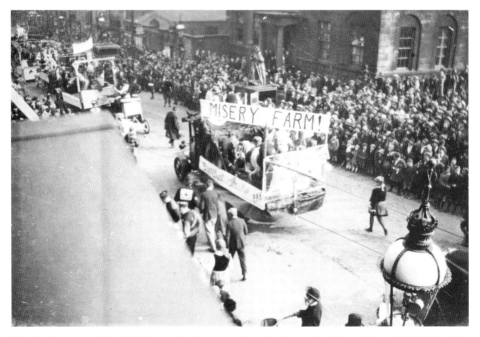

Birmingham people looked forward to the annual carnival organised by students of the University. Floats paraded, usually through the city centre, and tins were rattled to collect money for charities from the many bystanders who turned up even in bad weather. This scenes is from 1929.

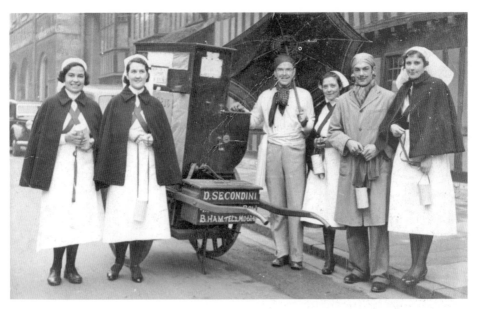

A carnival-type musical instrument – a barrel-organ or hurdy-gurdy. The collecting tins are being jangled to collect money for a nurse-supported good cause – the Hospital Saturday Fund. Dominic Secondini of Fazeley Street apparently had a barrel-organ for hire (1929–1938). The two men shown could be members of the medical staff.

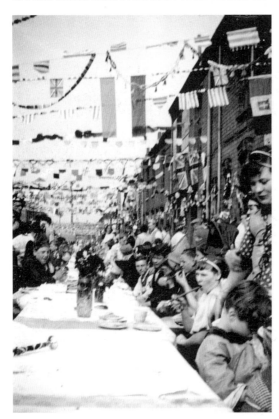

Living it up at a street party somewhere in Bordesley Green in 1937, in celebration of the Coronation of King George VI and Queen Elizabeth. There were many such events on May 12, when children were allowed a day off school.

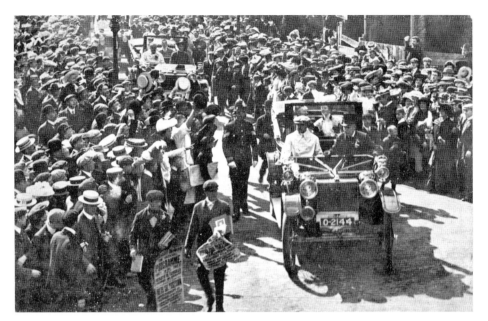

There can have been very few politicians who have evoked as much affection and esteem as 'radical Joe'. As is shown on this card and the next, thousands and thousands of Brummies turned out in streets and parks to cheer Joseph Chamberlain MP's seventieth birthday on 8 July 1906. Celebrations were held on Saturday 7 July and Monday 9 July, Sunday being the Sabbath. On the Saturday at 3.30 p.m. a motor car procession set off. Chamberlain and escort visited six parks, and concerts and firework displays were held.

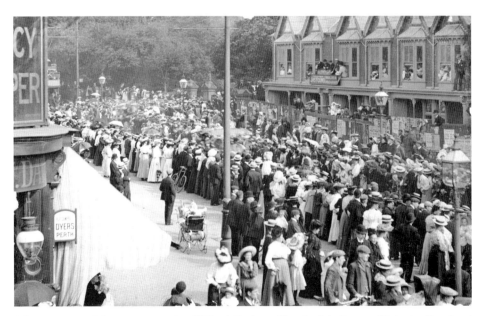

'This is a view of the entrance to Small Heath Park on Chamberlain Day ... We had a fine time.' This card was written by one who was there.

BIRMINGHAM
CENTENARY
CELEBRATIONS
1938

PAGEANT OF
BIRMINGHAM

ASTON PARK
11th to 16th JULY, 1938
PAGEANT MASTER - - *Gwen Lally*

ILLUSTRATED SOUVENIR BOOKLET 9ᵈ

This week-long pageant celebrated the centenary of Birmingham receiving its Royal Charter. Eight episodes of Birmingham's 'history' were put on show by the many ordinary but costumed residents from groups of suburbs. Notable occurrences like the Priestley Riots and the visit of Queen Victoria to Aston Park were re-enacted.

The main industries and important organizations of the City are next represented, by tableaux, many of which are in symbolic style mounted on floats, and by groups in typical or emblematic costumes, an element of comedy being obtained in certain cases by parody and caricature.

THE FLOATS will enter in the following order :—

THE CHURCHES

The next four represent the Municipal undertakings in which Birmingham leads the world :—

GAS WATER ELECTRIC SUPPLY
MUNICIPAL BANK

Followed by representations of Birmingham Industries :—

JEWELLERS & GUN TRADE BRASS & COPPER
SILVERSMITHS
 MOTOR & CYCLE TYRES
MOTOR CARS (2) ELECTRICAL ACCESSORIES
MOTOR CYCLES COMMERCIAL CARS ELECTRICAL TRADES
 WEIGHING MACHINES CHOCOLATE INDUSTRY

and representations of :—

BIRMINGHAM REPERTORY ART WOMEN'S LEAGUE OF
THEATRE SPORTS HEALTH & BEAUTY

Then Industries represented by Groups as follows :—

ALUMINIUM EDGE TOOLS
BUTTONS PINS

Other groups represent the following organisations :—

CYCLISTS

BOY SCOUTS' ASSOCIATION GIRL GUIDES' ASSOCIATION
BOYS' BRIGADE GIRLS' LIFE BRIGADE CHURCH LADS' BRIGADE

WARWICKSHIRE CADET BRIGADE

THE BRITISH RED CROSS SOCIETY ST. JOHN AMBULANCE BRIGADE

DISABLED EX-SERVICEMEN'S ASSOCIATION
(with V.A.D.)

ROYAL NAVY ARMY ROYAL AIR FORCE

After appropriate representation and display (including a Jewel ballet) the floats and groups will proceed to set positions during the general entrance of performers in all episodes, who in the background take formation around a centre piece emblematic of the City which is the pivot of the final picture symbolic of modern Birmingham

" THE HUB OF INDUSTRIAL ENGLAND "

25

Episode VIII displayed 'Modern & Industrial'. It would be interesting to speculate what might be shown on today's floats if a pageant were undertaken.

Episode VIII
(Including Grand Finale)

MODERN & INDUSTRIAL BIRMINGHAM
Devised and arranged, with commentary, by H. Gordon Toy

The final Episode brings us to modern and industrial Birmingham after opening with a cavalcade representative of Birmingham's famous citizens of the past. So many of the important figures were contemporaries that necessarily a great number have been omitted, and the selection is to some extent governed by chronological consideration.

THE CELEBRITIES will be introduced in the following order :—

JOHN BASKERVILLE (1700–1775) Pioneer of artistic printing.

WILLIAM HUTTON (1723–1815) Historian, Author and Topographer.

MATTHEW BOULTON (1728–1809) Celebrated Engineer and Collaborator with James Watt.

JAMES WATT (1736–1819) Inventor of the Steam Engine.

WILLIAM MURDOCK (1754–1839) Inventor and Pioneer of Coal Gas Lighting.

RICHARD TAPPER CADBURY (1768–1860) Prominent Quaker, Social and Civic Benefactor.

THOMAS ATTWOOD (1783–1856) One of the first two Birmingham Members of Parliament, and Founder of Reform League.

DAVID COX (1783–1859) Great Painter.

JOSEPH STURGE (1793–1859) Instrumental in the Abolition of Slavery. Temperance and Juvenile Welfare Pioneer.

SIR ROWLAND HILL (1795–1879) Founder of the Penny Post.

SIR JOSIAH MASON (1795–1881) Founder of the Orphanage and University.

CARDINAL J. H. NEWMAN (1801–1890) Great Theologian and Member of Oxford Movement.

JOHN BRIGHT (1811–1889) Great Statesman and Orator.

MISS RYLAND (1816–1892) Great Philanthropist to the City who also gave Cannon Hill and Small Heath Parks to the people.

GEORGE DIXON (1820–1898) Instrumental in securing Aston Hall for the City, and great Educationalist.

GEORGE DAWSON (1821–1876) Nonconformist Preacher, Municipal Reformer, and Founder of Public Library.

SIR E. BURNE-JONES (1833–1898) Artist and Designer in Stained Glass.

AND

THE RIGHT HONOURABLE JOSEPH CHAMBERLAIN
(1836–1914)

24

Also in Episode VIII appeared Birmingham celebrities as shown. Some real heavyweights are included. This statuesque 'celebrity' received far less public approbation: 'Outrageous', 'Scandalous', 'Whatever Next?', and probably lots of giggles were voiced about this supposed representation of a young smith symbolising the city's metalworking skills. Atop a floral fountain in Broad Street, the smith fell from grace and discreetly disappeared having been sculpted fig-leaf free.

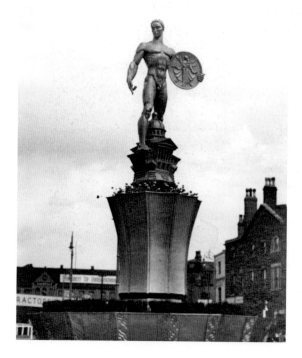

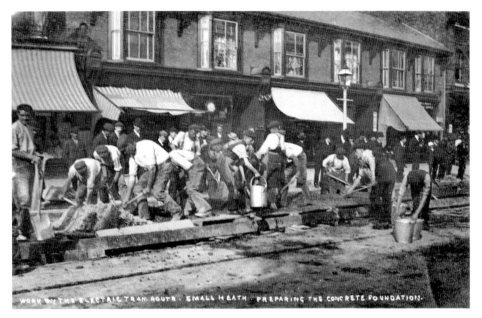

It is natural enough for people to be nosey. The following scenes show how people can turn up, uninvited, to observe and enjoy what they see. Rubbernecks? Maybe, but most of us like to watch other people at work, especially if that work is interesting in itself. Above is a group of navvies preparing the foundations for the first electric tram route to Small Heath.

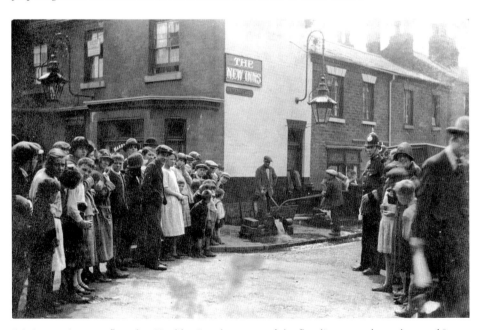

It is interesting to reflect that Hockley Brook, source of the flooding, once formed part of James Watt's water power system for his Soho factory. Given that the men are pumping water from the cellar of the New Inns pub, local interest is keen in the pursuit of 'Well, what are they doing about it?'

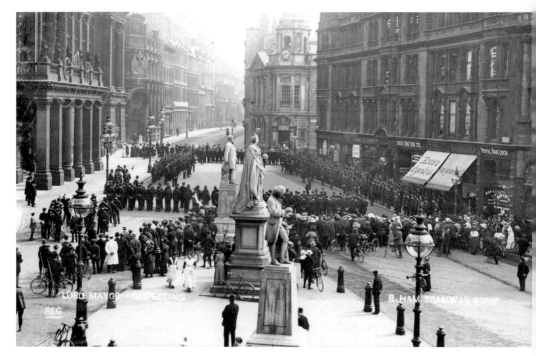

Victoria Square, fronting the seat of local government, was an ideal location for outdoor events of public interest. Faint lettering on the card's back reads, 'Lord Mayor inspecting B'ham Tramway Staff'. The card is franked 17 June 1911. By this time, the Council was in competent control of the city's tramway services. To the right of Queen Victoria's statue stands that of James Watt.

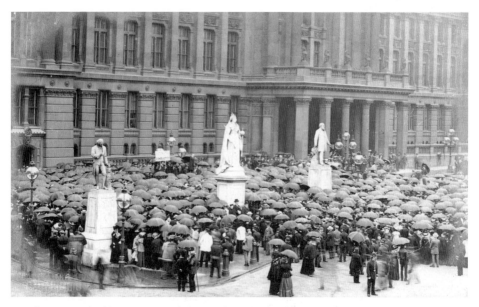

No, this is not a publicity stunt to promote the sale of umbrellas although it was later modified for that purpose by an enterprising Birmingham manufacturer. In the background, a placard is being held aloft by two men, the visible word at the bottom being, 'Conductor'. Whoever is conducting what, the crowd seem interested.

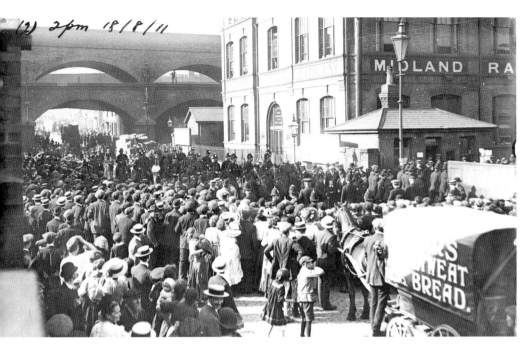

Near Saltley Road station, a cast of hundreds waits in a state of nervy expectation. Mounted police are present; so are soldiers. Presumed striking railway workers are no doubt present, while presumed non-strikers bring the horses and wagons into the yard, hence their escort. Sightseers, including children, are also present. This photograph is one of a number that show different times as the drama unfolds.

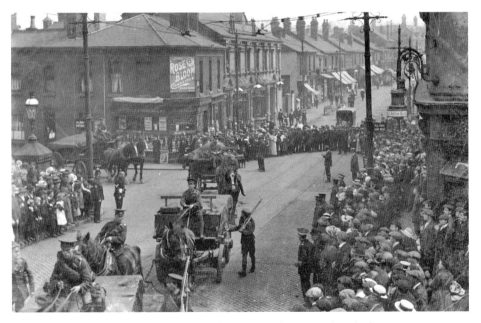

High Street, Saltley and crowds have turned out to watch presumed packed armaments going to war. Given the interest shown in this convoy, the First World War has not long started. The corner pub, right, sells Ansell's Aston Ales.

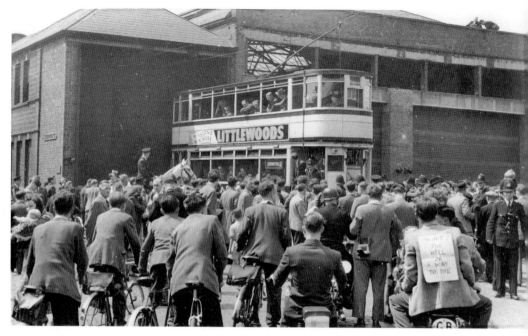

'And so we say farewell to' (usually some exotic Pacific isle, revealed by a travelogue film at the News Theatre) – but on this occasion, a farewell to a Birmingham tram shed. Tram buffs have turned up in numbers to pay their respects to the city's last trams. Littlewoods, the football pools firm (see page 14) will need to find new advertising space. It is 1953.

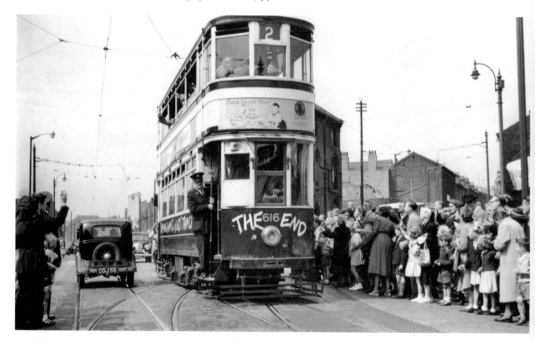

On the tram services' last day, 4 July 1953, the public turned up in force along the route taken by the last tram on its last journey to the terminus in Erdington. 'Well done, Old Timer' summed up the general feeling.